BRITAIN IN OLD PHOTOGRAPHS

MANCHESTER

A THIRD SELECTION

CHRIS MAKEPEACE

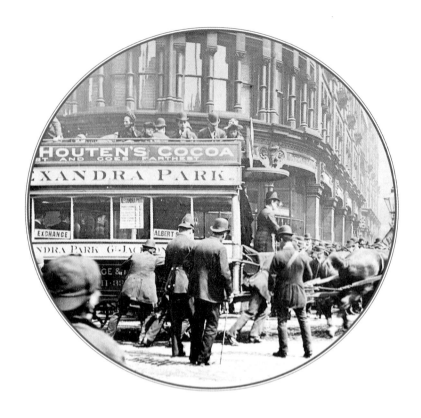

SUTTON PUBLISHING LIMITED

Sutton Publishing Limited
Phoenix Mill · Thrupp · Stroud
Gloucestershire · GL5 2BU

First published 2000
Reprinted in 2002

Typeset in 10/12 Photina.
Typesetting and origination by
Sutton Publishing Limited.
Printed and bound in England by
J.H. Haynes Co. Ltd, Sparkford.

British Library Cataloguing in Publication Data
A catalogue record for this book is available from the British Library.

ISBN 0-7509-1775-X

Title page photograph: This incident, photographed in the 1890s, appears to have taken place at the junction of St Mary's Gate and Deansgate when tram H33, based at one of the depots in the Harpurhey area, was operating the service between central Manchester and Alexandra Park. The incident also appears to have attracted a large crowd of bystanders, while some of the passengers on the upper deck look down on what has happened with interest as the tram wheels are re-railed.

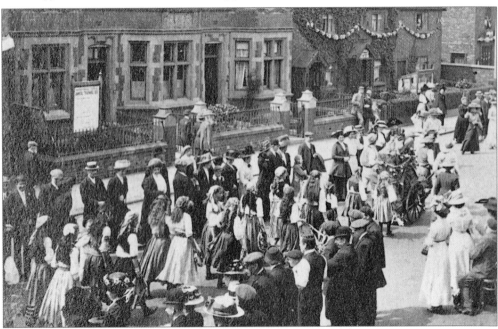

To mark the coronation of George V in 1911 the residents of Didsbury organised a procession through the centre of the village. In this photograph, the procession is seen passing along Wilmslow Road in front of the police station. Although the police station had not been decorated for the occasion, occupants of other buildings in the centre of the village put up bunting and flags to mark the day. The earliest reference to a police station in Didsbury dates from 1890 although directories indicate that there was a police constable named Francis Allan living at 80 Wilmslow Road for a number of years before it was recorded as a police station. According to the 1905 directory, Didsbury had a sergeant and two police constables. It is not known how many officers there were in 1911 as the directory only refers to the sergeant in charge, who was named John William Armstrong. Next door to the police station, at 76 and 78 Wilmslow Road, were the premises of Peacocks, undertakers. Some of the entries in the directories of the late nineteenth century refer to William Peacock as being a joiner and a builder while in other years he is described as an undertaker. For many years, the house next to Peacock's was occupied by William Hulme or Holme, a brick setter.

CONTENTS

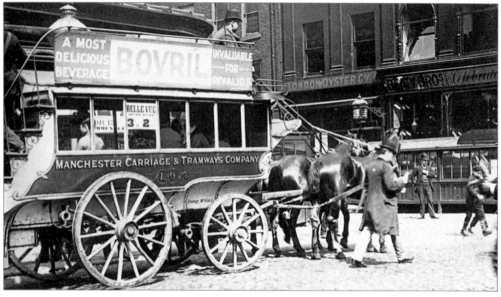

One of the many horse buses that operated in Manchester before the introduction of the horse trams waits near Victoria Buildings, St Mary's Gate, before setting off on its journey to Belle Vue sometime after 1880. This route was converted to horse tram operation in the late 1870s, but horse buses continued to be used to provide additional services at certain times of the day and to serve the outlying districts where the construction of a tramway was not economic. This bus, L9, was based in Longsight, possibly at the Grey Street Depot, and was built to the designs of John Eades. It is not clear from the photograph whether the bus is in its original condition with the top deck seating facing outwards or whether it has been rebuilt with the seating facing towards the front. Note that if you travelled outside, you paid less for your journey. Just above the front wheel is the name of the secretary of the Manchester Carriage and Tramways Company, David McGill.

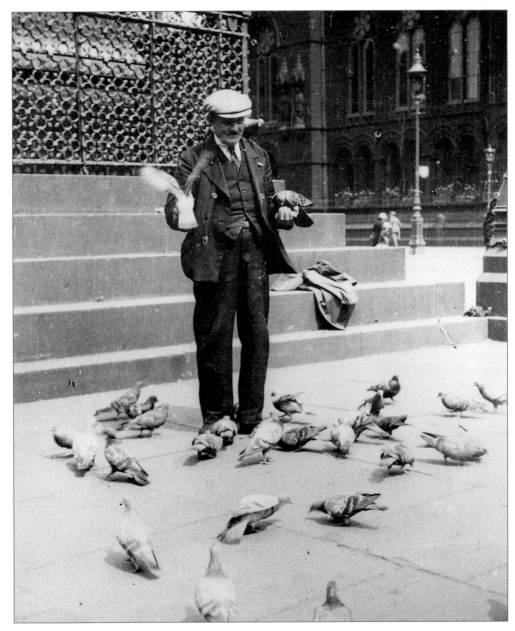

Pigeons and starlings are among the most common birds in the centre of towns and cities. They congregate in such large numbers partly because waste food is thrown out by restaurants, cafés and snack bars, but also members of the public feed them. This photograph shows a man feeding the pigeons in Albert Square, possibly in the 1930s. In the background is the Town Hall while to the left are the ornamental railings around the base of the Albert Memorial – they were designed to prevent members of the public climbing on the monument. Pigeons have presented a serious problem in Manchester and other cities for many years as they roost on ledges and window sills, coating everything with a layer of droppings which does little to enhance the appearance of buildings and can cause serious damage to the stone work. Various methods have been tried to keep the birds away, including the use of a very fine mesh netting which does not detract from the appearance of the building.

INTRODUCTION

The end of the twentieth century, irrespective of whether 2000 or 2001 is the start of the new one, provides an opportunity to look back at the history of Manchester and recall some of the events that have influenced its development over the 150 years since the advent of photography. After all, it is the photograph that has made this book possible.

It might be said that photography was a kind of watershed in that it enabled things to be preserved accurately in pictorial form for the first time. Before the invention of the camera, artists recorded what they saw, but only included in paintings and drawings what they felt was most attractive and tended to ignore the more unpleasant side of their subject. With the invention of the camera, it became possible to record exactly what was there, although sometimes the stage was carefully set to get the best results. Today, with digital cameras, there are ways of altering how a photographic image turns out, thus weakening the statement that 'the camera never lies'.

The importance of the camera as a means of recording the present for the future was recognised early in its development. In about 1874, an article in the *Builder* suggested that photography ought to be used to record all the historical buildings of a town before they were demolished in the name of redevelopment and suggested that such records were kept in libraries or museums. Twenty years later, Manchester Amateur Photographic Society made just such a survey of Manchester and Salford, although it should be pointed out that photographers such as James Mudd, Fischer and Brothers had already been recording the town since the mid-1850s. Some of the photographs in this book, and the previous two volumes in the series, were taken by these very able photographers. It is also fortunate that at the end of the nineteenth century, the City Engineer's Department started using photography to record the town and that organisations, like the Manchester and Salford Methodist Mission, began to use photographs to illustrate their annual reports. In the twentieth century, newspapers started to use photographs to accompany stories – another important step forward.

Manchester, like all towns, has been affected by events, both local and national. For example, at the end of the Napoleonic Wars in 1815 many of those who were discharged from the forces headed for the growing industrial towns rather than their former homes in the countryside. Central Manchester's population rose from around 42,000 in 1788 to almost 187,000 in 1851. The effect of major twentieth-century wars was different, however: they involved the whole population in some way or other. For instance, the air raids of the Second World War destroyed not only military targets, but also the homes and workplaces of those who were not directly involved in the fighting.

Looking back over the 150 years since the first photographs of Manchester were taken, what have been the watersheds or events that have influenced the growth and development of 'this capital of the spinners and weavers of the world', as Reach put it in 1849?

It appears that the approach of 1900 did not generate the same level of discussion about when the new century would begin as there has been in recent times. According to one article there was no argument – the twentieth century began on 1 January 1901. In some respects, the death of Queen Victoria early in 1901 seemed to reinforce the idea that a new century had begun, but in reality the 'Naughty Nineties' merged into Edwardian England. A different head gradually began to appear on coins and stamps, but there was no announcement 'All change. It is now the twentieth century' or 'It is now the Edwardian period'. Life went on very much as it always had done for the vast majority. The outbreak of war in 1914 was to have a far more dramatic effect on people's lives.

Although the pace of change was probably more rapid in the twentieth century, the nineteenth century saw many important and dramatic developments which affected everyone's lives. For example, the fastest means of travel in 1815 was the canal or the horse. Railways carrying passengers hauled by steam engines were still fifteen years in the future when the Liverpool and Manchester Railway opened and introduced a gradual reduction in what might be called 'time distance' – by this I mean journeys that would have taken several hours or days could now be completed in a few hours. For example, the trip from Manchester to Liverpool took virtually all day by canal and several hours by stage coach, but by 1900 it was only 43 minutes on a non-stop train from Manchester Central station.

Railways were intended to carry goods as well as passengers, but Manchester's greatest desire in freight transportation was a direct link to the sea. This was achieved in 1894 with the opening of the Manchester Ship Canal, which enabled ocean-going vessels to dock within a couple of miles of the Town Hall. More recently, the airport has been the centre of expansion both in passenger traffic and freight sent overseas. However, the growth of freight traffic has to a large extent been the result of the changing nature of the goods made in Manchester. Until well into the twentieth century items for export tended to be heavy and bulky, ideal for transport by sea but not by air. Today exports tend to be small, high-value items which are ideal for air freight.

In 1815, the majority of people lived in the countryside, but the 1851 census revealed that over half the country's population lived in towns of more than 10,000. At the same time there was a movement of the middle classes into the countryside, encouraged by the growth of more efficient transport – the railways and, in urban areas, the horse-drawn bus and later the horse-drawn tram. The first horse-drawn buses were operating in Manchester in 1824 and the first horse-drawn trams in 1877. By 1901, electricity was beginning to be used for public transport and for the wealthy, private cars were beginning to replace carriages. Changes in transport prompted the outward expansion of Manchester and the growth of residential suburbs.

This was further encouraged by the fact that industry and commerce took over old residential areas in the centre of the city, forcing the residents to move away. This trend continued in the twentieth century with slum clearance programmes which involved not only the remaining poor quality houses in the centre of the city, but also in the surrounding inner suburbs such as Ardwick, Hulme and Chorlton-on-Medlock. People from these areas were decanted into districts like Withington, Fallowfield, Wythenshawe and, since 1945, outside the boundaries of the city to places like Hattersley, Handforth and Middleton where overspill estates were constructed by the City Council's housing department.

The nineteenth century was a period of new ideas. In the 1830s and 1840s, the concept of free trade took hold and then gathered momentum as the century progressed.

The principle behind it was a move to get rid of as much red tape relating to exports as possible. However, by the end of the nineteenth century protectionism had reared its head and there was a growing demand for Britain to impose tariffs to protect its own industry from foreign competition. In some respects one can see a parallel today with the European Union and the same splits between and within political parties – protectionism v free trade – as there were in the late nineteenth century. It is interesting to note that among the strongest supporters of free trade in the nineteenth century were the textile manufacturers of Lancashire, but in the twentieth century the same industry has been seeking quotas and tariffs to protect it from foreign competition.

But what of other changes in the nineteenth century? Gas began to be used for lighting and by the 1890s many houses were lit using it; gas was also used for heating, cooking and providing hot water. By 1900, the supremacy of gas was being threatened by the arrival of a new industry – electricity.

The supply of clean water is taken for granted today, but this was not the case in 1815 when people relied on wells, water tanks, rivers and streams for their supply. In the middle of the nineteenth century, Manchester became the first town to look outside its boundaries for clean water. In the late 1840s and early 1850s, major engineering works were completed in the Longdendale valley which resulted in the construction of the Longdendale Reservoirs to supply the city and its neighbours. By the 1870s, Manchester discovered that it again needed to increase the supply to meet the growing demand and began to draw water from the Lake District via the Thirlmere Aqueduct. At the same time, the existence of adequate supplies ensured that an effective sewage disposal system could be introduced. The result was the construction of the Davyhulme Sewage Works on the edge of the Manchester Ship Canal. Not only was Manchester involved in trying to clean up its act, its neighbours, like Withington Local Board of Health, did the same. Withington built its own sewage works on the banks of the River Mersey at Chorlton and this also handled sewage from Levenshulme.

Other areas of life where change was also very noticeable in the nineteenth century included education. By the end of the century, elementary education was compulsory and secondary and further education were beginning to grow with the appearance of new universities and colleges. School boards of the 1870s and 1880s gave way in the 1900s to local authority education committees.

In the field of social care, there were also changes. The old Elizabethan Poor Law had been replaced in the 1830s by the New Poor Law, characterised by the dreaded 'bastilles', as some called the new, more efficient and cost-effective workhouses, but these were changing by the end of the nineteenth century. Voluntary organisations began to make their mark in helping those who had fallen on hard times.

Attempts were made to remove the slums. The 1844 Police Act in Manchester banned the construction of houses without adequate sanitary facilities while the Artisans Dwellings Act of the 1880s, and its subsequent amendments, resulted in local authorities being able to encourage the building of new houses to established standards. It was not, however, until after 1919 that housing and the clearance of the slums became an important priority for both central and local government.

New hospitals, particularly specialist ones, also made an appearance in the nineteenth century while medicine made important advances. And developments came even faster during the twentieth century. Old hospitals were replaced by new ones, but it was not until 1948 that medical treatment became available to all through the National Health Service. During the early twentieth century, those who could not afford a doctor still had

to rely on charity to get treatment. Some diseases appeared in the nineteenth century, but improvements in social conditions resulted in their being brought under control. Epidemics of cholera and typhoid were countered by improvements in water supply while smallpox was brought under control by vaccination and the realisation that isolation could stop illnesses spreading. The appointment of medical officers of health was an important step forward in the area of prevention, as even the smallest local boards of health had their own part-time medical officer of health, often a local doctor.

Local government was also shaken up in the nineteenth century. The Municipal Corporations Act of 1835 reformed local government and provided a means by which growing industrial towns, like Manchester, were able to apply for charters of incorporation as boroughs. This meant they could adopt a more efficient method of administration and dispense with other forms of government, some manorial in origin. Other changes, such as the creation of new local government structures including local boards of health, resulted from the fear that slums were developing in the areas around towns that were not under any form of municipal control. In 1888 county councils were introduced and in the 1890s urban district councils, with wider powers than their predecessors, took over from local boards of health. In 1885, Manchester began to enlarge its area of jurisdiction by taking over neighbouring local boards and urban district councils such as Bradford and Rusholme in 1885 and Moston, Blackley, Crumpsall, Openshaw, Newton Heath and part of Gorton in 1890. This was two years after a proposal to create a Manchester County Council, similar to the London County Council, was put forward and rejected. The twentieth century opened with Manchester continuing its expansionist policy by taking in Heaton Park in 1903, Moss Side, Withington, Didsbury and Chorlton-cum-Hardy in 1904, Levenshulme and West Gorton in 1909, Wythenshawe in 1931 and Ringway in 1974.

The nineteenth century was also an important period culturally. Theatres flourished, libraries and museums came into existence, art galleries were opened and books became more common place as prices began to fall. Even newspaper circulation rose, especially after the abolition of the newspaper tax in 1851. Manchester was the first place to have a public library under the terms of the 1850 Public Libraries Act – Manchester Free Library opened in September 1852 in a converted building. The purpose-built Central Library in St Peter's Square did not open until 1934. Manchester City Art Gallery was

Opposite: St Mary's Gate is one of central Manchester's oldest streets. It linked Market Street with Deansgate. The name may have arisen because it led to a pre-Conquest church that originally stood close to the corner of Exchange Street and St Ann's Square. The street is mentioned in the earliest surviving Court Leet records of 1552 as having its own scavengers and by-lawmen. According to the 1690 Manchester Poll Book, twenty-one households with a total of forty-five people were recorded for St Mary's Gate. When the first directory for Manchester was published in 1772, thirteen people were listed as living here, although it should be remembered that the directory was not comprehensive. A similar number are listed for 1800, including Edward Holme, a doctor, and John Ollivant, a silversmith, who founded the well-known Manchester firm of Ollivant and Botsford. This postcard view of St Mary's Gate was taken in about 1904, looking towards Market Street. On the left is Victoria Buildings, which was destroyed in the Christmas blitz of 1940. The tower in the centre is that of the Royal Exchange while to its right can be seen buildings which had shops at street level and offices on the upper floors, and the entrance to the Exchange Arcade (extreme right). When the photograph was taken, among the firms that had retail premises here were the Maypole Dairy Company (nos 2–4), Lockhart's Café (no. 8) and Burgons, who were grocers (no. 12).

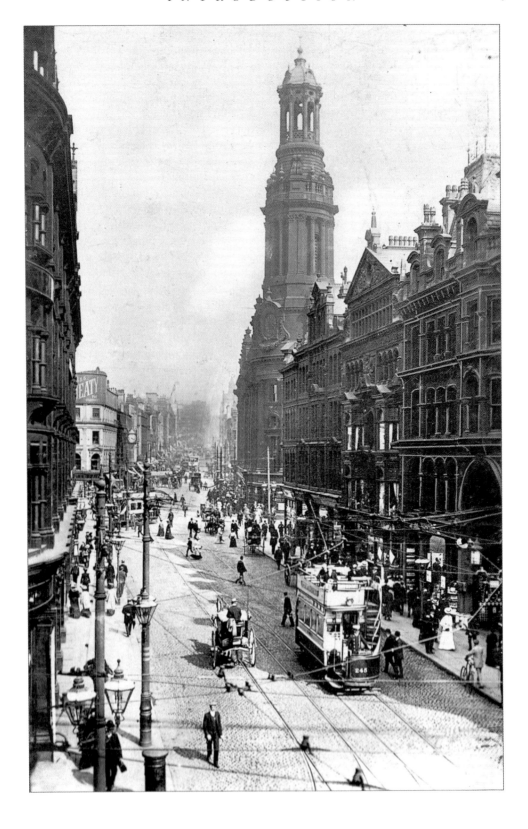

acquired by the City Council in the 1880s when its owners, the Royal Manchester
Institution, found that they could not afford to maintain it and continue to add to
collections. By the twentieth century, space for the collections was limited but recently a
much-needed extension has been begun. Musically, the group formed by Sir Charles
Hallé for the Art Treasures Exhibition of 1857 was to lead to the foundation of the Hallé
Orchestra in the following year. It provided regular concerts for the general public at
affordable prices. However, Hallé's dream of a purpose-built concert hall was not realised
until the 1990s. The twentieth century saw many changes in Manchester's cultural life,
with live theatre being replaced by cinema, although with the opening of the Royal
Exchange Theatre in the 1970s there was a revival of that art form.

The nineteenth and twentieth centuries witnessed many changes in Manchester's
appearance. Old, familiar buildings disappeared and were replaced by new ones. For
example, the Infirmary moved from Piccadilly to a new site in Chorlton-on-Medlock and
the old building was demolished, leaving an open space which today is prompting great
controversy. The former Town Hall on King Street was declared unsafe and the Free
Reference Library which was housed there was forced to find temporary accommodation.
The Gentlemen's Concert Hall, the People's Concert Hall and Lower Mosley Street
Schools were demolished to make way for the Midland Hotel, and the former Natural
History Museum in Peter Street was replaced by a new YMCA building. This was the
period when the north side of Deansgate was cleared and Deansgate itself was partially
widened. The Great Northern Warehouse was also built, completing the clearance of an
area of poor quality housing between Watson Street, Deansgate, Great Bridgewater Street
and Peter Street.

Over the 150 years since the first photographs were taken in Manchester, much has
changed. Buildings have been erected, torn down and replaced. The way people travel,
live, work, spend their leisure time and are governed has also altered dramatically. Many
of these changes have been recorded by the camera to the benefit of the present
generation of local historians. It is the current generation's task to ensure that the
present day is recorded photographically so that in another 150 years it will be possible
to look back to see how we lived and worked at the end of the twentieth and the
beginning of the twenty-first centuries. There will be other watersheds in the history of
Manchester, but will they be as significant as those in the past? It is not possible to say at
present. Only time will tell.

CENTRAL MANCHESTER

To many people, Manchester appears on a map as a long, sausage-shaped area, but this is only the present-day city. The origins of Manchester proper lay in a relatively small area bounded on the south by the River Medlock and on the north and north-east by the rivers Irwell and Irk. This is the township of Manchester and was the only area referred to by that name until the creation of the borough in 1838.

Until the last half of the eighteenth century, Manchester was a small, compact area which could be crossed in about half an hour. Even in the 1780s it was said that it was possible to stand in Piccadilly and watch the hunt in Ardwick. In fact, until the construction of the Infirmary in Piccadilly in 1754–5, the only building in this area was Alkrington Hall, the town house of the Lever family, which was sold in 1786 and converted into the White Bear Inn. In 1757, the population of the township was only about 17,000 people, but within a short period, it exceeded 22,000, almost doubling by 1788 to around 42,000. When the first census was taken, it had risen to over 70,000 and continued to rise until the 1850s when it reached 180,000. By 1850, almost all the open space in Manchester had been built on, either for commercial buildings or houses, with as much as possible squeezed on to the available space. Back-to-back houses, course dwellings and other sub-standard housing were constructed as quickly as possible. Little thought was given to the need for sanitary facilities or running water. It is little wonder that diseases such as typhus and typhoid were endemic and that cholera spread rapidly in 1832.

It was not until after 1851 that the population of what was to become central Manchester began to decline, albeit rather slowly at first. This trend gradually gathered momentum as the nineteenth century progressed, fuelled not by the desire to escape the poor conditions, but by the pressures of commerce and the retail trade for space to erect new warehouses, shops and offices. This movement had already been noted in the 1840s when Mosley Street was transformed from a thoroughfare lined with gentlemen's and merchants' houses to one of warehouses, offices and public buildings. This was the time when churches like Mosley Street Unitarian Chapel, Mosley Street Independent Chapel and St Chad's Roman Catholic Church on Rook Street moved to what are often described today as the 'inner city suburbs'.

Possibly one of the most dramatic effects of commercial development on the population and on the nature of the buildings in central Manchester took place in the 1870s when Central station was built. Twenty years later, the Great Northern Railway's warehouse was erected. In the area covered by these two buildings, there were some 6,500 people in 1865. When the area was redeveloped, the people had to find new homes. Some moved into the adjacent districts of Hulme and Chorlton-on-Medlock while

others moved to the New Cross area. The effect on central Manchester was dramatic. Churches like St Matthew's on Liverpool Road and St Peter's in St Peter's Square felt the effect quickly as their congregations declined. On the other side of the township, St Paul's Church on Turner Street was closed and replaced by St Paul's New Cross in the 1870s. St Clement's on Lever Street was also closed in the 1870s and the money from the sale of the site was used to build and endow churches in areas including Openshaw and Chorlton-on-Medlock. St Mary's in Parsonage Gardens was also closed as a result of the declining population of the area. The local magazine *Sphinx* visited several of these inner city churches in the 1860s and referred to them as 'Manchester's deserted churches', most having a congregation of only a few people. The article on St James's Church in George Street referred to its congregation as having changed from those of a 'better sort' to one where the main worshippers were 'of a lesser sort'.

During the twentieth century, the decline in the population of central Manchester accelerated, but more recently, this has been reversed with warehouses being converted into desirable residential accommodation and even purpose-built housing has begun to make an appearance. In some respects, history is repeating itself in that the centre of Manchester, or rather the former township of Manchester, is now regaining some of its lost inhabitants. Even trams reappeared in the last decade, providing an efficient alternative to the motor car as a means of commuting into the central area from places like Bury, Altrincham and, more recently, from Salford Quays and Eccles. In some respects, Manchester is rediscovering itself and emphasising its status as a regional centre.

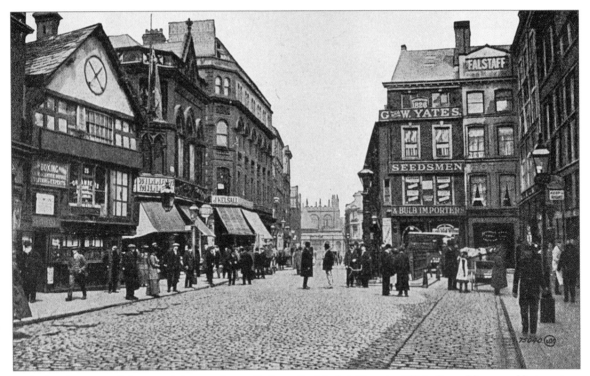

With the clearance of the remaining market stalls from the Market Place in 1891, the public was able to gain a proper impression of the size of the Market Place and how small it was compared with other towns. The changes also allowed the buildings that surrounded the Market Place to be seen without obstructions for the first time. Also clearly visible is Old Millgate with the east end of the Cathedral closing the view. This road is believed to have been named because of the presence many centuries before of a water mill on the River Dene, which flowed down Withy Grove; its role was later taken over by the mills on the River Irk. When the area was redeveloped in the 1960s and 1970s, Old Millgate was restricted to a simple pedestrian footpath alongside a modern building, but in the post-1996 redevelopment all traces of Old Millgate have been completely obliterated. Among the buildings that can be seen in this photograph are the Wellington Inn, the Cotton Waste Exchange, which also housed the Coal Exchange, Yates, who were suppliers of plants and seeds, and the Falstaff Hotel.

Opposite: There are two other photographs of St Mary's Gate in this volume, both taken in the early twentieth century (see pages 5 and 15). This particular image was taken shortly after the IRA bomb blast on 16 June 1996 and shows the full effect of the blast on the Market Place development and the bridge over Market Street. Today, all this has changed yet again: the City Council took the opportunity afforded by the damage to reconsider how the centre of Manchester should look.

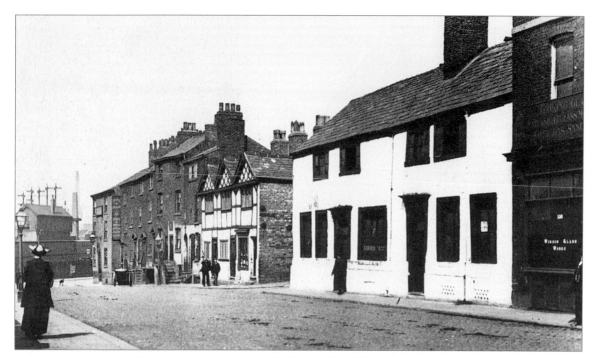

Another of central Manchester's old streets which still follows its original line and retains many of its twists and turns is Long Millgate. Until about 1850, Long Millgate extended from Fennel Street to Red Bank, but with the construction of Corporation Street it was divided into two sections. This photograph shows the section between Corporation Street and Red Bank, which drops down to the River Irk, flowing by this time underneath the railway viaduct leading to Victoria station. Most of the houses in this section appear to date from the mid-eighteenth century, as Manchester's population began to rise, although the building with three gables in the centre may be earlier as it appears to have timber framing. When this photograph was taken in the late nineteenth or early twentieth centuries, this part of Long Millgate was still largely residential in character.

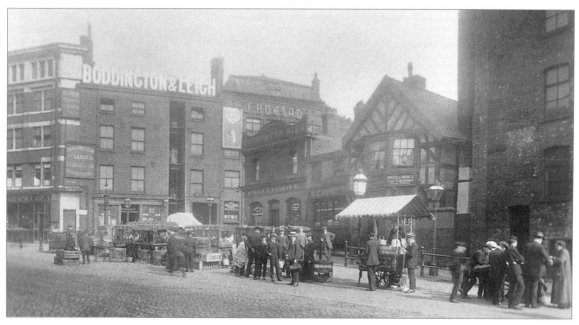

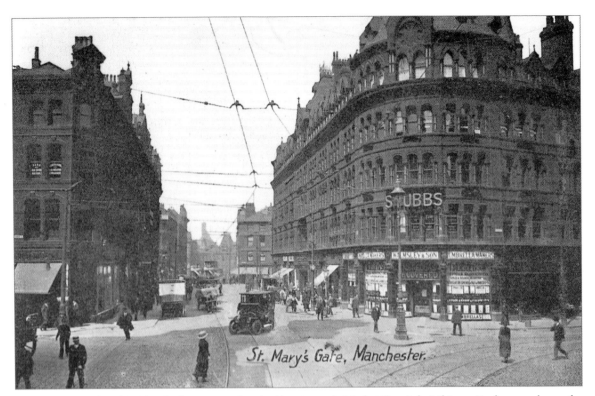

St. Mary's Gate, Manchester.

Many photographs of St Mary's Gate were taken looking towards Market Street, but this particular one shows the view in the opposite direction towards Blackfriars Street and Bridge. The prominent structure on the right is Victoria Buildings, designed by William Dawes and completed in 1878 on the site of an area known as Smithy Door. Its construction was encouraged by the City Council because it felt that there was a serious shortage of good quality shops in the St Mary's Gate/Victoria Street and Deansgate area. Victoria Buildings incorporated shops at street level, offices on the upper floor and, as the site was triangular, a hotel overlooking the junction of Deansgate and Victoria Street. Running through the building was a shopping arcade. The site was an awkward one as it sloped downhill towards the river. Consequently, the shops which fronted Deansgate had very high ceilings and several of them were able to install a mezzanine floor to provide additional space. Victoria Buildings was destroyed in 1940 and the site was landscaped until the late 1960s when it was incorporated in the Market Place redevelopment. Today, as a result of the IRA bomb in 1996, the area has been redeveloped yet again. In the background are the buildings lining Blackfriars Street, which were mainly warehouses and offices.

Opposite, bottom: For many years part of Withy Grove and Shudehill was the home of a street market. Originally, it was the hen and poultry market, but latterly it was the location for open-air secondhand book stalls. This photograph, taken towards the end of the nineteenth century, shows the area when it was the hen and poultry market on what was a relatively quiet day with only a few stalls around. In the background several warehouses can be seen as well as the Rovers Return, the black and white building, which was demolished in 1957. Today, the whole of this area is covered by the Arndale Centre while the stalls, which now appear to concentrate on records rather than books, have been moved to the corner of High Street and Church Street. The market is but a shadow of its former self.

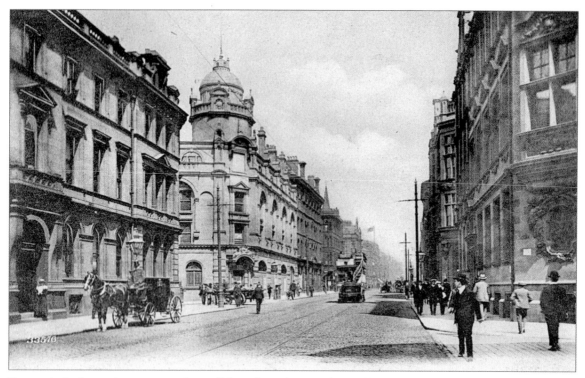

Deansgate is the main east–west thoroughfare through central Manchester and is always busy, although this particular postcard from *c.* 1904 seems to give a somewhat different impression. The photograph was taken looking along Deansgate towards central Manchester. The building on the right was originally the Manchester School Board premises and was on the corner of Jackson's Row. Most of it was taken up with offices and what would today be called interview rooms for the staff of the board and for inspectors, but on the first floor was the boardroom. When the Manchester School Board ceased to exist in 1903, the building was taken over by Manchester's Education Department, which continued to use it until its offices in Crown Square were completed in the 1960s. After a period as Manchester's main register office, the building has now been converted into a restaurant. On the left is the building which was formerly used by the Inland Revenue, but is now part of the Crown Court. Beyond are premises which housed several offices as well as the Manchester premises of the *Daily Mail*. This building was demolished and replaced in about 1932 by Northcliffe House, which included facilities for the *Daily Mail* to be printed in Manchester. In about 1968 the *Manchester Evening News* and the *Guardian* moved from Cross Street to share these premises with the *Daily Mail*, but now all three papers have moved out of central Manchester and the site has been redeveloped as a hotel. These buildings, erected in the last two decades of the nineteenth century, gave Deansgate an impressive appearance and make it a kind of grand entry into the city centre proper.

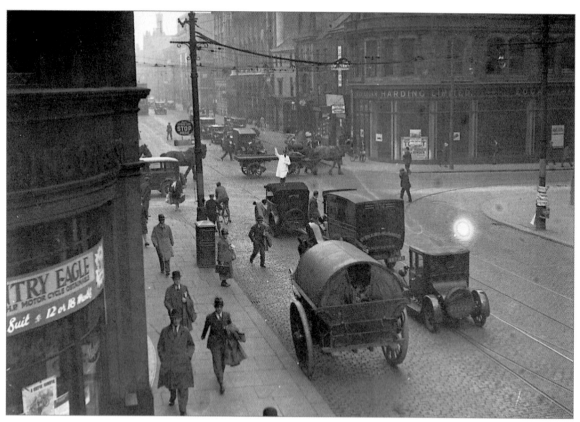

According to the note on this photograph from the early 1920s, it is intended to show a traffic jam at the junction of Deansgate, Peter Street and Quay Street, although by the standards of the late twentieth century traffic is flowing smoothly and only waiting for the policeman on point duty to allow it to start moving again. The junction of Quay Street, Peter Street and Deansgate was created in the 1740s when Quay Street was constructed to link the main road with the newly completed warehouse and quay on the River Irwell. At that time, there was a short row of cottages across the road from Quay Street on a road known as Yates Street, which was extended to meet Oxford Street at St Peter's Church in about 1793 and was renamed Peter Street. The photograph also shows two of the houses which were built on Deansgate as the road developed in the nineteenth century – these are the two low buildings next to the one with the cross. Eventually, they were demolished and replaced by new buildings after the Second World War.

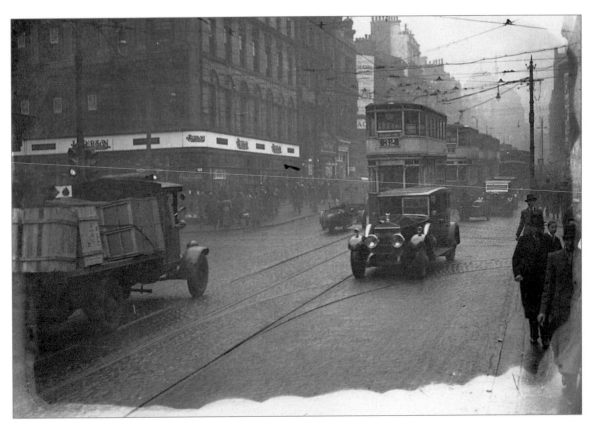

Throughout the latter half of the nineteenth century there were complaints about traffic congestion on Market
Street and how dangerous it was to cross. In the early twentieth century there were proposals to pedestrianise
Market Street and turn Cannon Street into a dual carriageway. However, nothing was done and Market Street
continued to be a source of problems until 1986 when it was closed to traffic. During the first half of the twentieth
century traffic congestion was made worse by the trams which ran in the centre of the road, meaning that other
road-users had to pass between the trams and the pavement as can be seen in this photograph of the junction of
Cross Street, Market Street and Corporation Street in the 1930s. It was suggested on several occasions that trams
should not be allowed to go down Market Street but should terminate in Piccadilly on the grounds that this would
reduce traffic congestion and that it was quicker to walk along Market Street than travel in a tram. The line of
trams stretching along Market Street certainly reinforces that impression because once one tram had stopped to
pick up passengers, others had to wait, causing delays and further congestion. The building on the corner of
Corporation Street and Market Street, occupied by Burton's, was originally the premises of J. & S. Moss,
gentlemen's outfitters, who opened on this site in the early 1930s.

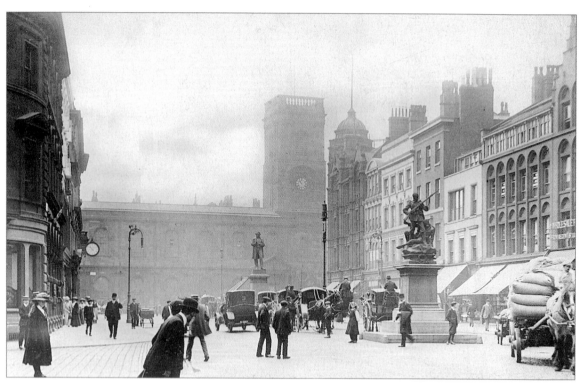

St Ann's Square came into existence in the early eighteenth century when part of Acres Fields was used for the construction of St Ann's Church, which was consecrated in 1712. The Act of Parliament which authorised its construction also laid down that there had to be space left between any buildings that might be erected so that the annual fair could continue to be held there. This fair started in 1222 and was eventually moved in 1821 as it was considered not to be a suitable event to be held in what was becoming a fashionable shopping area. During the nineteenth century, the original residential properties that once lined the square were replaced by buildings which had shops at street level and offices on the upper floors. By the middle of the nineteenth century, St Ann's Square had taken on the appearance which it has in this postcard with the statue of Richard Cobden, one of the leaders of the Anti-Corn Law League, and the memorial to those who had fallen in the Boer War. According to the directory for 1912, the year this postcard was sent, the occupiers of the buildings on the right included Verey's Limited (ladies outfitters), Mappin & Webb (silversmiths), Stephenson & Sons (glass and earthenware dealers), Emma Wilson (milliner), J.E. Cornish (bookseller) and Thomas Parker & Sons (cooks and confectioners). Among the professions to be found in the offices above the shops were solicitors, cotton merchants, estate agents, accountants, an architect and a consulting engineer. The building on the extreme left of the photograph was demolished shortly after the end of the First World War to make way for the extension to the Royal Exchange.

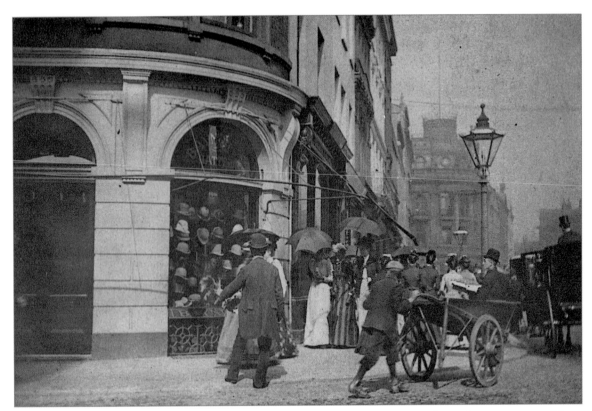

The corner of St Ann's Street and St Ann's Square has always been very busy with people passing to and from Deansgate to Cross Street and into St Ann's Square. This photograph was taken in the early 1890s as part of the first photographic survey of Manchester and Salford and shows Baynes & Co., hatters, at 23 St Ann's Street. This firm appears to have been in existence for only a short time because by 1901 no. 23 was not recorded in the directory although next door at no. 21 there was a café. By the 1920s, the building shown in this picture had been replaced by a new one which was occupied by Weatherall's, outfitters. St Ann's Street, which links Deansgate with Cross Street, was originally known as Toll Lane; it was the only means of access into Acres Field where the annual Michaelmas fair was held. As late as the 1820s, it was still the only way to get into Cross Street because there was no proper entrance to the latter from Market Street.

Opposite, bottom: One of the busiest junctions in central Manchester was at the point where Cross Street and Corporation Street met Market Street. The area around the Royal Exchange was always very busy with pedestrians because of the number of offices in the Royal Exchange building itself and the fact that Corporation Street was the main access to Victoria station, one of Manchester's busiest. To these people were added those who arrived at Exchange station and made their way to the Exchange and the various financial institutions in and around the King Street area. In April 1914, a survey of both road and pedestrian traffic within a 1-mile radius of the Exchange showed that in a 24-hour period, over 1.13 million people entered the area, of whom over 440,000 were on foot, over 425,000 used the trams and 206,000 came by train. The survey also found that there were almost 100,000 vehicle movements past the 76 observation points that had been set up, of which almost 19,000 were tram car movements. The survey concluded that there had been a 5 per cent increase in traffic since 1911, when the first such survey had been held, and that there was also a 16.7 per cent increase in motor cars and 7.8 per cent increase in heavy motors, presumably meaning goods vehicles. This photograph accompanied the report and shows what purports to be ordinary traffic controlled by a policeman. Another illustration, on the back cover, shows the junction without a policeman on point duty. The newspaper headline is worthy of note: it reads 'Buckingham Palace Intruder. Court appeal for . . .' The rest is not easily legible, but could the missing word be 'clemency'?

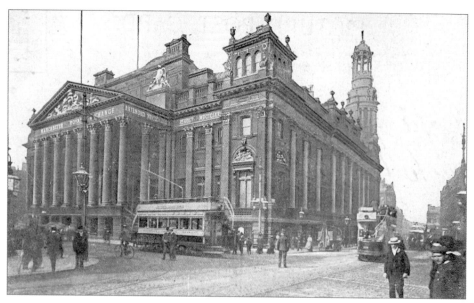

One of the clues in dating postcards is a postmark, but sometimes postmarks can be very misleading. The postmark on this card is 25 April 1925, but the evidence in the picture indicates that the original photograph was taken during the Edwardian period as the trams are open top. There is a further clue to the fact that the photograph may date from either 1902 or 1903 because just to the right of the electric tram is what appears to be either a horse-drawn tram or bus and these were phased out in the first two or three years of the twentieth century. The main building in the photograph is the Cross Street façade of the Royal Exchange which was taken down when the Exchange was enlarged after the First World War. The demolition of this impressive portico was carried out at the request of Manchester City Council which wanted to widen Cross Street and agreed not to oppose the plans for the extension if the portico was removed. Although the scene at the corner of Cross Street and Market Street looked relatively peaceful when the photograph was taken, it was a hive of activity on Tuesdays and Thursdays, which were days of 'High 'Change' at the Royal Exchange.

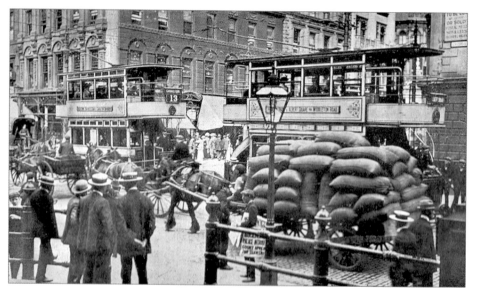

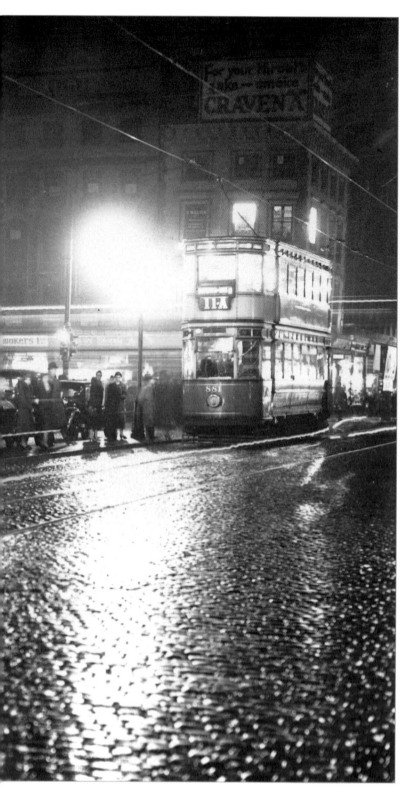

An evening tram waits for the traffic lights at the junction of Cross Street, Market Street and Corporation Street on a wet night in the 1930s. Behind the line of cars, also waiting at the lights, is the ground floor of the Royal Exchange which was occupied by retail premises. The use of the ground floor for shops was a feature of many buildings erected in the latter half of the nineteenth century because of the high cost of land. The shop with all the lights on is Boots the Chemist, which first appeared in the 1923 directory as occupying the Market Street/Cross Street corner of the Exchange. The problem of servicing the shops in the Royal Exchange was solved in a novel way when it was enlarged. A special lift was constructed at the end of Bank Street which allowed a vehicle to be lowered into the basement. At the end of the underground service road there was a turntable so that the vehicle could be turned round and leave the building facing the correct way to drive out. Today, all new major shopping developments have an area for service vehicles, but the one at the Royal Exchange was among the earliest to be constructed and helped to reduce traffic congestion in the area.

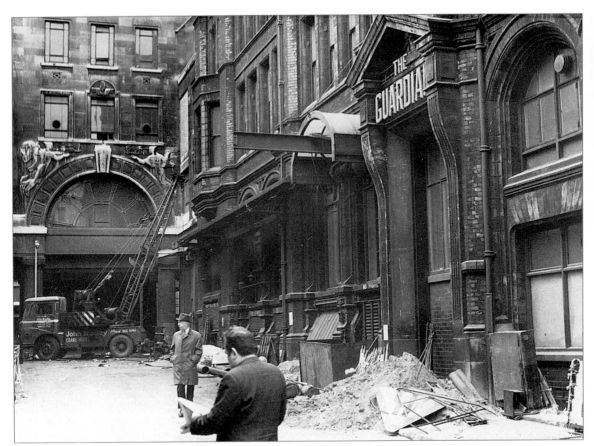

For almost a century, Cross Street was associated with the *Manchester Guardian*, founded in 1821 as the voice of liberalism in Manchester. Originally, it was a weekly, but as the nineteenth century progressed it was published first twice a week and eventually became a daily. In 1868, the *Manchester Guardian* acquired the *Manchester Evening News*, founded to support the election campaign of Mitchell Henry who was dissatisfied with the coverage of his campaign to elected a Liberal MP for Manchester. The move was not unexpected as both papers shared the same liberal outlook on events. In 1886, both papers moved into purpose-built premises on Cross Street, which included editorial offices, newsrooms and presses. In 1959, the *Manchester Guardian* changed its name, dropping the word *Manchester* from its mast-head, a move which recognised its national readership. Both newspapers remained at Cross Street until about 1968 when the site was required for part of the Arndale development. Coincidentally, the move came at a time when new technology was beginning to appear, the buildings needed modernising and access to them for lorries carrying newsprint was not easy. A decision was taken to move from Cross Street and share the same building and presses as the *Daily Mail* on Deansgate, although there were no connections between the two papers. This photograph shows the beginning of the demolition work on the old *Manchester Guardian* and *Evening News* buildings, severing the link this part of Cross Street had had with the newspaper industry since the first half of the nineteenth century.

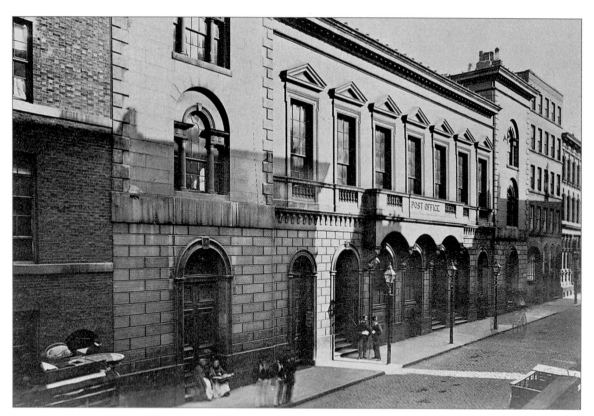

Manchester's original post office was in the Market Place, but when the Exchange opened in 1809, provision was made for it to be located there. However, with the introduction of the Penny Post, the post office was moved to its own building on Brown Street. It was argued that everyone had a right of access to the post office and that it should not be located in a building whose owners could exclude people without a good reason. The Brown Street building was enlarged in 1861, but the growing pressure on services and the increase in the number of letters and parcels handled resulted in the need for new accommodation. This was opened in 1884 and cost £120,000. The new post office not only included counter facilities, but also sorting offices. In 1890, the postmaster claimed that the sorting office handled 2 million letters, parcels and newspapers each week and this had risen to 4 million by 1900. It was claimed in 1895 that Manchester was responsible for about one-twelfth of all correspondence that emanated from the United Kingdom and was second only to London in the amount of post it generated. This photograph shows the building as it appeared in 1866 after its enlargement.

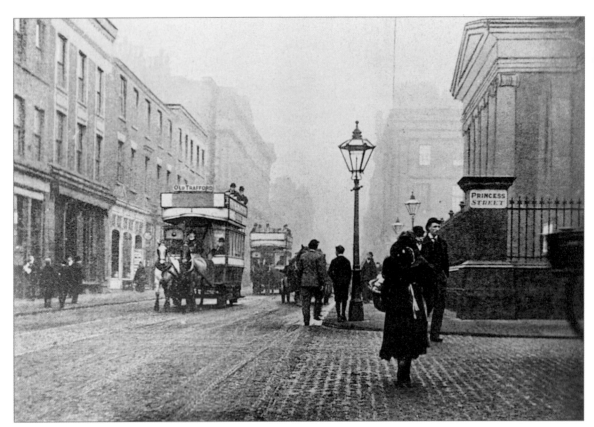

During the latter half of the eighteenth century, several new streets were created on the south side of the built-up area as landowners, like the Mosley family, began to sell the property they held there. One of the earliest of the new roads was Mosley Street. It was not entirely residential in character as several public buildings were to be found there. The earliest of these was Mosley Street Unitarian Chapel, which stood at the corner of Mosley Street and Marble Street (on a site now occupied by the Bradford & Bingley Building Society) between 1788 and 1834 when it moved to Upper Brook Street. In the same year, Mosley Street Independent Chapel was opened at the corner of Mosley Street and Charlotte Street, where it remained until 1848 when it moved to All Saints, becoming known as the Cavendish Street Chapel. In 1792, on the opposite corner to the Independent Chapel, the Manchester Assembly Rooms were opened. The Assembly Rooms were regarded as one of the most fashionable places in early nineteenth-century Manchester, but with changing tastes and the outward movement of the membership to the suburbs, they were closed in 1850 and the building was demolished. At the end of the eighteenth century the Manchester Academy fronted Mosley Street between Princess Street and St Peter's Square. John Dalton, the scientist who discovered colour blindness and the atomic theory, taught there from 1793 until the academy moved to York in 1803. An important building erected in the early nineteenth century was the Portico Library and Newsroom, designed by Thomas Harrison and opened in 1806; here members could read the current papers and borrow books. In this photograph of Mosley Street in the 1890s the building on the right is the Manchester City Art Gallery, designed by Sir Charles Barry for the Royal Manchester Institution and completed in 1829, while behind it is the Union Club, opened in 1825.

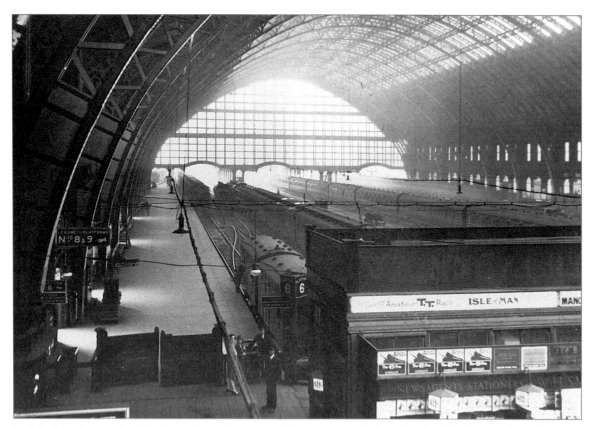

In July 1880, the Cheshire Lines Committee opened its new terminal station in Manchester. Central station replaced a temporary one on Watson Street that had opened in 1877. The main feature of the new station was a 210ft single-span arch, the third largest in the country, which is clearly seen in this photograph taken in about 1930. Unfortunately, the office block and hotel planned for the front of the station were never constructed which gave it the appearance of only being partially completed. Central was used by trains from three different companies: Manchester, Sheffield & Lincolnshire Railway; the Midland Railway; and the Great Northern Railway. Trains, or through coaches, from Central station ran to Chester and Liverpool as well as to London (St Pancras) via the Peak District, to Sheffield and to many other parts of the country. It was the Cheshire Lines Committee that introduced the policy of rounding fares down so that passengers and staff did not have to deal with small change – if the fare was 2s 7½d, it was rounded down to 2s 6d. The company also developed a reputation for efficiency, especially on its services to Liverpool, which were completed in 43 minutes non-stop or 45 minutes if a stop was made at Warrington. Central was one of the busiest of Manchester's commuter stations with passengers arriving from expanding residential areas like Flixton and Urmston to the west, and Withington, Didsbury and Chorlton-cum-Hardy to the south. Not all of the platforms were to be found under the arched roof. There were a couple on the Lower Mosley Street side of the station which handled local services; access to them was by the sign indicating the way to platforms 8 and 9. Today, the station has been converted into the GMEX exhibition centre.

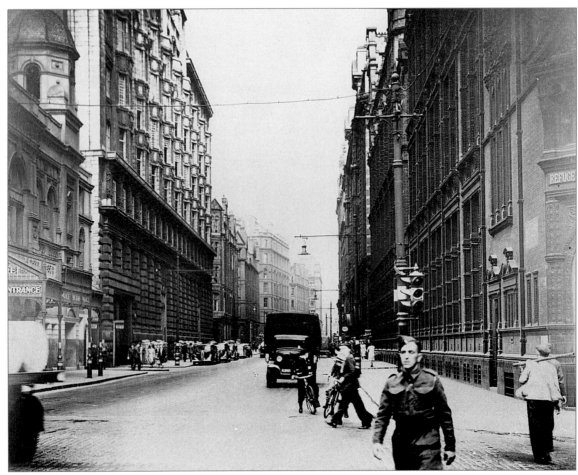

During the first decade of the twentieth century, the section of Whitworth Street between Princess Street and Oxford Street underwent a dramatic transformation. The canal wharves in the area were sold for development. Several large and impressive warehouses were erected which gave the street the appearance of a canyon, clearly visible in this 1940 photograph. Some of the new warehouses were owned by Lloyd's Packing Company which leased the space at a low rent on condition that Lloyd's despatched all the goods that left the buildings. On the left is the Palace Theatre while on the right are the offices of the Refuge Assurance Company, which extended its frontage onto Whitworth Street in the 1930s. Today, several of these large warehouses have been converted into apartments while the former Refuge building is now a hotel.

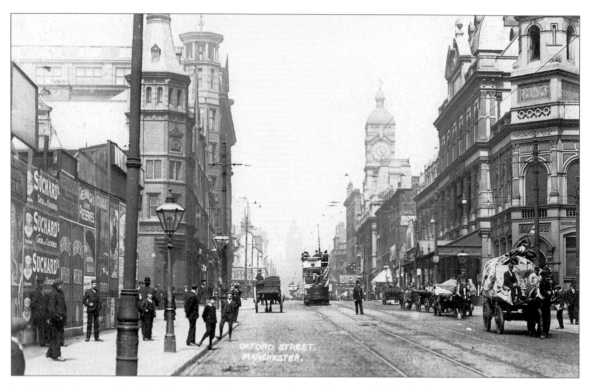

In the late nineteenth and early twentieth centuries the southern end of Oxford Street underwent a dramatic transformation. The four corner sites at the junction of Oxford Street with Whitworth Street and Gloucester Street (later to become Whitworth Street West) became available for development and four new buildings were erected. Two of these, the Palace Theatre, completed in 1892 on the northern corner of Whitworth Street and Oxford Street, and St Mary's Hospital, completed in 1893 on the corner of Whitworth Street West and Oxford Street, are shown in this photograph. The other new buildings were the Refuge Insurance Offices, built between Whitworth Street and the railway line to Oxford Road station, the first part of which was completed in the 1890s, and a furniture shop, Shaws, at the junction of Oxford Street, Whitworth Street West and the approach to Oxford Road station, which was built in around 1905. In this picture, the site of the furniture shop is surrounded by hoardings. The tower in the middle distance is that of the St James's theatre, opened in the 1880s and closed in 1910, which described itself as the home of 'heavy drama'. Next to it was the St James's Hall, which was used for exhibitions of all kinds as well as for early cinematograph shows. These were eventually replaced by St James's Buildings. Just beyond the horse-drawn cart on the left is another vacant site which was to be developed as the Hippodrome, completed in 1904. In order to advertise what was being built, the developers have put a large notice around the top of the hoarding which prevents unauthorised access to a dangerous construction site. The tower which appears to be in the centre of Oxford Street is that of St Peter's Church, which was closed in 1906 and demolished in 1907, the outward movement of population from the area reducing the size of the congregation attending the church to virtually nothing.

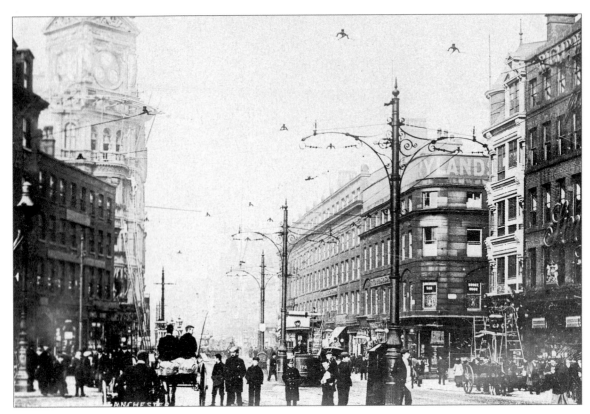

Although the junction of Market Street, Cross Street and Corporation Street was regarded as one of the busiest in central Manchester, another hectic spot was the junction of Market Street, Piccadilly, Mosley Street and George Street by the Royal Hotel. In this photograph of the junction, taken in about 1903 or 1904, pedestrians, horse-drawn wagons and electric trams all vie for space. On the left of the picture is the Royal Hotel and Lewis's store while the large block of buildings on the right was the hub of the Rylands empire. The firm of John Rylands & Sons was established in 1823 by John Rylands when he came to Manchester from Wigan and set up a textile warehouse. Gradually, he expanded his interests to include spinning cotton, weaving and bleaching cloth and making cloth into clothing and other household items. His mills and works were scattered throughout the Manchester area from Wigan to Gorton, as well as being at Crewe. It is claimed that his firm was a good example of an integrated business, controlling everything from manufacturing the raw materials through to selling the finished product. John Rylands gradually extended the size of his warehouse in Manchester until it covered the area between High Street and Tib Lane and fronted on to Market Street. As well as clothing and household fabric, the firm also moved into making and selling furniture, some of it being manufactured at the former cotton mills on Oxford Road which were eventually demolished to make way for the Regal Twins, a cinema complex built in the early 1930s. John Rylands died a wealthy man, leaving over £1 million. His third wife used some of her fortune to establish the John Rylands Library on Deansgate. John Rylands lived his last thirty years at Longford Hall in Stretford, where he pursued his interest in gardening. He is said to have worked from 8 a.m. to 6 p.m., even when he was an old man.

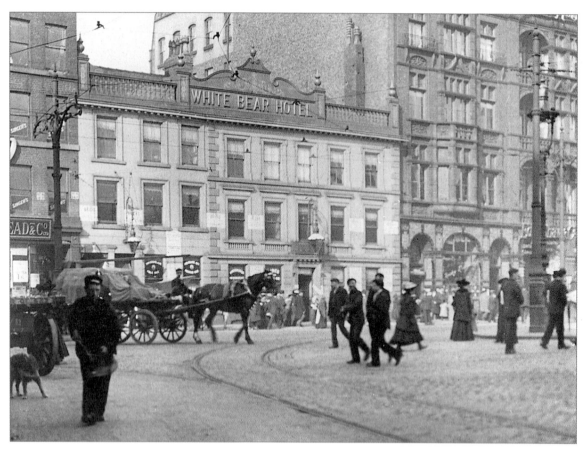

Until the middle of the eighteenth century, the only building in what is now known as Piccadilly was Alkrington Hall, the town house of the Lever family. It was said to have been a black-and-white, half-timbered building with a small garden in the front. The Levers last used the building in 1771 when it was advertised for sale, the suggested uses being an inn or a school. By this time Piccadilly, or Lever's Row as it was known, was becoming more important because the Infirmary was located nearby. The building was sold in 1772 to John Travis, who converted it into an inn. Whether Travis gave it the name of the White Bear is uncertain but by 1801 it had become a coaching inn. A contemporary advertisement claimed that 'the only coach from Manchester to London without changing, the London and Manchester commercial post coach sets off from the above inn every Sunday, Tuesday and Thursday, to the Golden Cross, Charing Cross, in thirty-six hours, being quicker than any except the mail coaches'. However, the White Bear, seen here in 1904, was never a leading inn for long-distance coaches, although it was the starting and arrival point for the services that covered the local communities. During the nineteenth century, it was said to have been a popular place of entertainment for 'Manchester's tradesfolk' – this meant the men rather than their masters. The building was sold in the early twentieth century and demolished to be replaced by a restaurant.

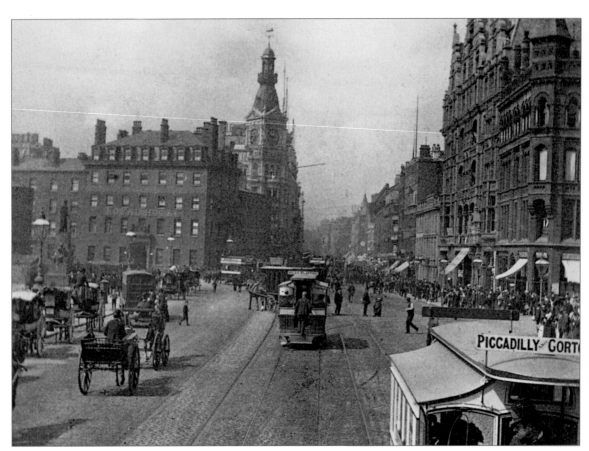

This is the view you might have had if you were sitting on the upper deck of a horse-drawn tram entering Piccadilly in the 1890s. On the left is the Bridgewater Arms and Royal Hotel, built as a private residence around 1772 and converted into a hotel in 1828 when the Bridgewater Arms was displaced from High Street by warehouse developments. Beyond the hotel is the famous tower of Lewis's department store, which opened its doors in Manchester in 1877 and rapidly established itself as an important force in the city's retail trade. Not only did the store open on Saturdays, but it was also proud to deliver to the suburban area three times a day. Its market was the growing number of office and warehouse workers who poured into Manchester each day from residential suburbs like Rusholme, Fallowfield and Levenshulme. On the right is a building used by Black and Green, tea merchants, and next to it is the Mosley Hotel and beyond that, the White Bear. The Mosley Hotel moved to Piccadilly in the 1820s when its original premises on Market Street were required for road widening. In 1891 the Mosley Hotel was again demolished and a new hotel erected on an enlarged site; it was described as the 'largest and most commodious hotel' in Manchester with a clientele from all parts of the world.

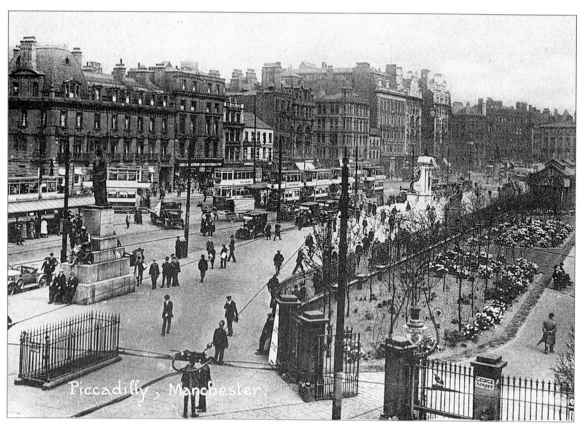

During the first forty years of the twentieth century, Piccadilly underwent a series of changes. The demolition of the Manchester Royal Infirmary in 1910 resulted in the creation of a large open space and the council spent a considerable amount of time discussing what to do with it. However, in 1912, when the former Town Hall at the corner of Cross Street and King Street was declared to be structurally dangerous, temporary huts were erected on part of the former Infirmary site to house the reference library. These huts can be seen on the right of the photograph, just beyond the landscaped area. The building on the left-hand side of the picture is the Albion Hotel which was closed and demolished in 1926, the site being used for a new Woolworth's store. Next door to the Albion Hotel is a building which was demolished in about 1926 or 1927 to make way for a new bank at street level and offices on the upper floors. In 1928, the latter were taken over by the BBC as its Manchester studios.

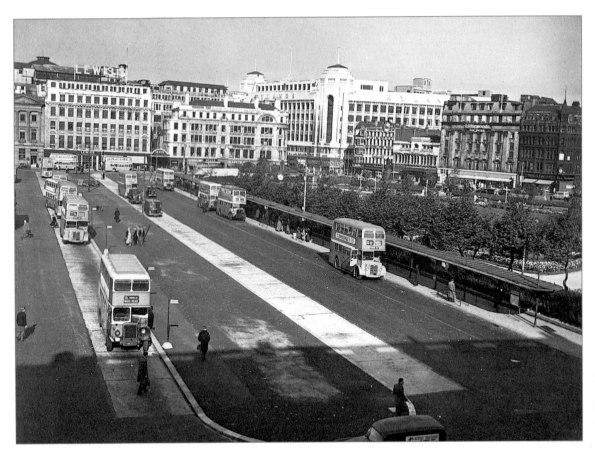

This image of Piccadilly and the gardens is considerably less cluttered than the previous one. A large part of central Manchester had been damaged in the Christmas blitz of 1940 and the work of reconstruction and redesigning part of central Manchester was just beginning to get under way when this photograph was taken in 1957. Parker Street bus station in the foreground was created in the 1930s to reduce the congestion so apparent in the previous photograph – it looks very bleak in this picture. Although some bus shelters have been erected close to Piccadilly Gardens, passengers waiting for buses which departed from the central part of the station had to brave the elements. Eventually, shelters were erected to protect them. Today, Metrolink has its Piccadilly station where the buses are waiting, close to the gardens, and the whole area is being refurbished and improved. The photograph also shows how the landscaping of the gardens themselves had become well established, providing a pleasant, green, open area in the centre of the city. In the background are the buildings housing three of Manchester's largest shops – Lewis's, Rylands and Littlewoods.

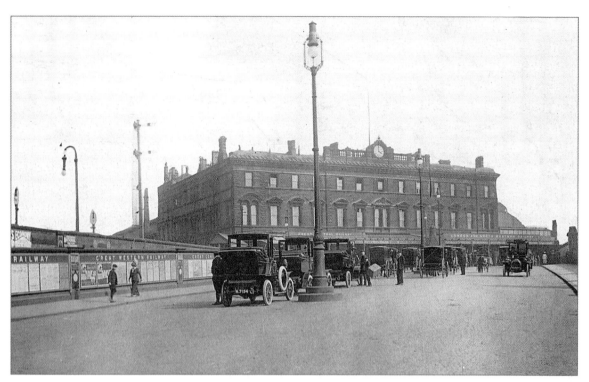

London Road station, now known as Piccadilly station, was the terminus on the south side of Manchester for the London & North Western Railway (LNWR) and also the Manchester terminus for the Manchester, Sheffield & Lincolnshire Railway (MS & L). The original station, built by the Manchester & Birmingham Railway, later part of the LNWR, was opened in 1842 and consisted of two platforms, one for arrivals and the other for departures. The station was rebuilt between 1860 and 1866 to cater for the rapidly growing number of people travelling by train. The office building in the centre of the picture was jointly shared by the two companies, whose relationship in the 1840s and 1850s was far from cordial. When the station was rebuilt, not only was there a fence erected between the platforms used by the different companies, but they were even designated differently: the MS & L lettered its platforms while the LNWR used numbers. By the right-hand edge of the office block is the arched roof covering platforms 8 to 12 which were constructed by the LNWR in the 1880s to cater for the increased commuter traffic and the milk traffic from north Cheshire. On the left is a signal arm which controlled access to the MS & L's goods yard and warehouse which was located at the side of the approach to the station where Gateway House and the station car parks are now located. The office building in front of the station was replaced in 1958 when British Railways began a programme of modernisation and electrified the line to London. (J. Ryan)

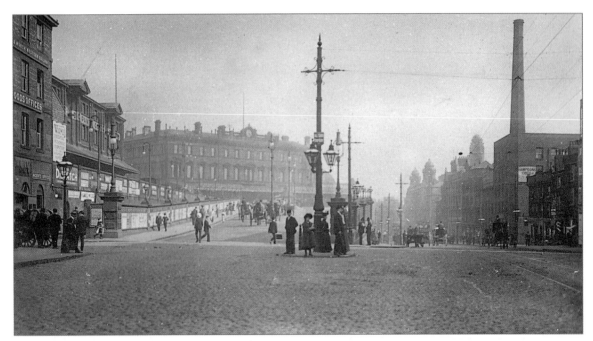

London Road station was built at the end of a viaduct which carried the railway over the River Medlock and gave a level approach to the station. Initially, access was via steps from Store Street, but in the 1850s, an approach road was constructed which allowed vehicles to take passengers and goods right up to the front of the station. This photograph from the early twentieth century shows the approach road, which was used by taxis and hansom cabs, together with the warehouse belonging to the Manchester, Sheffield & Lincolnshire Railway (left). To the right of the station approach is the beginning of London Road, which drops down to cross the River Medlock near where Mancunian Way now crosses the main road. The chimney on the right is part of a cotton mill, of which there were several on London Road in the nineteenth and early twentieth centuries. One mill has been preserved and converted into a hotel, a reminder of the days when this part of central Manchester was industrial. The two cupolas in the background are on the London Road façade of the fire station, completed in 1904. This must have been a very dangerous junction for pedestrians to deal with in the days before lights and crossings. From the photograph, it appears that the island occupied by the street light and the column for the overhead tram wires was used as a refuge by those waiting for a gap in the traffic. (*J. Ryan*)

Opposite, top: The approach to Piccadilly station (the modern name for London Road station), *c.* 1970. Central to the photograph is the 'lazy S' of Gateway House, which is said to have been developed from a doodle on a menu. The building replaced the railway warehouses which formerly stood on the site. When this photograph was taken, the shop units had still to be let. To the right of Gateway House are the offices and booking hall of the station, which replaced the 1860s building when British Railways decided a new development was more in keeping with its modern image. Behind the booking hall are the arches of what is often referred to as the 'train shed' but is the place where trains arrive and depart. The 'train shed', the basic structure of which dates from the mid-nineteenth century, has recently been refurbished and the details on its columns have been picked out.

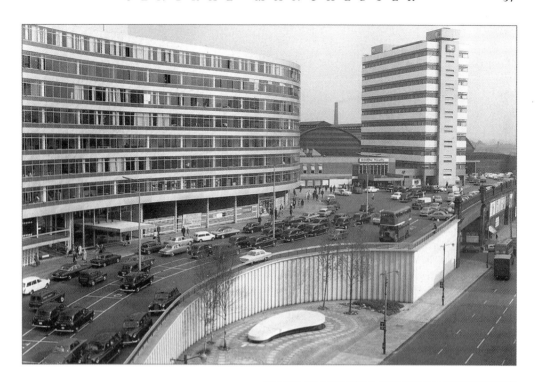

In 1820, a new Roman Catholic church
was opened on the edge of Manchester –
St Augustine's, Granby Row. This church
rapidly attracted a large congregation as well
as a reputation for fine singing. It is said that
when there were visiting Italian opera
companies in Manchester, they would
augment the church choir and give
performances which attracted a large number
of non-Catholics to hear mass being sung. The
church closed in 1906 and the congregation
moved to York Street in Chorlton-on-Medlock.
The reason for the closure was not the
declining population of the area, but because
the noise and vibration caused by machinery
and equipment at the nearby College of
Technology (now UMIST) affected the building
and disturbed worshippers. This postcard,
dating from about 1905, shows the interior of
St Augustine's church with its high vaulted
roof, which must have produced very good
acoustics for the singers. The replacement
church was destroyed in 1940 during the
Christmas blitz and worshippers eventually
merged with another Catholic congregation to
form a new church at All Saints.

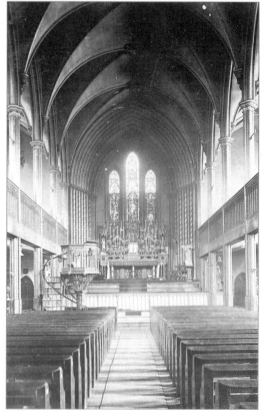

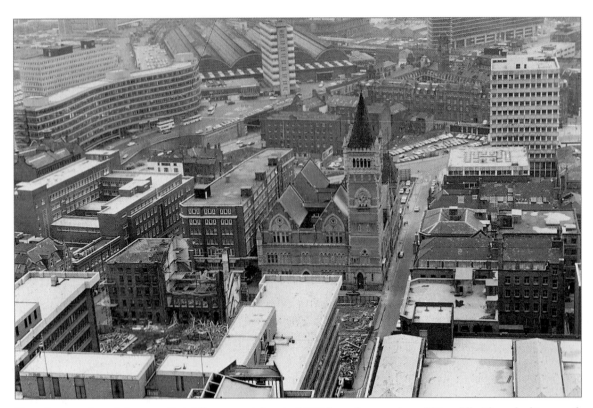

This photograph and the ones that follow were taken in 1979 from the very top of Piccadilly Plaza, looking south towards Piccadilly station. The view is dominated by the Minshull Street police courts, now a crown court, which were designed by Thomas Worthington and opened in 1868. During the 1990s, the building was refurbished and extended after the building to the left of the original courts was demolished. In the top left-hand corner is Gateway House, often described as being in the shape of a 'lazy S', which was built on the site of the former Manchester, Sheffield & Lincolnshire Railway goods warehouses. In the background is Piccadilly station with the arches which cover the platforms clearly visible, together with the modern tower block which was erected when the station was modernised in the early 1960s. The view also shows the triangular shape of London Road fire station, opened in 1904, while in front of it are the remains of two cotton mills, which have since been converted into a hotel.

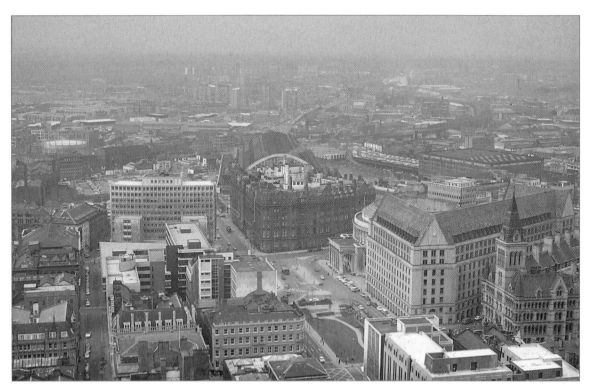

Looking westwards from the roof of Piccadilly Plaza, along Mosley Street, it is possible to see the Midland Hotel (centre), the former Central station (behind) and the Town Hall extension (right) together with the roof of the Art Gallery and a small part of Central Library and the Town Hall. The former Central station was opened in 1880 and the Midland Hotel in 1904. Adjacent to the former Central station is the Great Northern Railway company's warehouse, opened in 1898, which was one of the earliest steel-framed structures in the country. When this photograph was taken, the railway no longer used the warehouse or the adjacent railway sidings. The place which they once occupied had been turned into car parks to cater for the growing number of people who travelled into Manchester by car. The tall white building on the left is Peter House. It partially covers the site of the former Prince's Theatre, which closed in 1940.

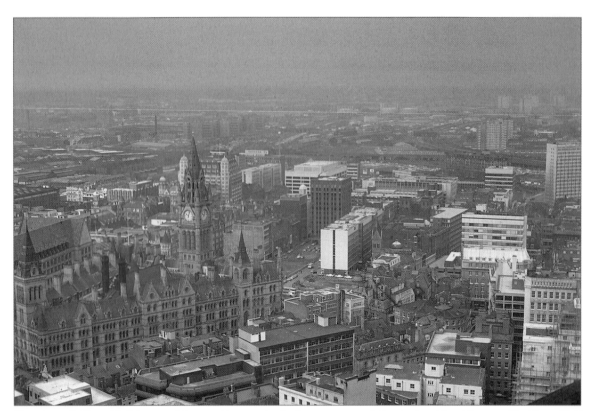

Manchester's Town Hall is one of the most impressive in the country and dominates Albert Square. The Town Hall dominates the left-hand side of this photograph with its Princess Street elevation clearly visible. On the opposite side of the Albert Square, facing the Town Hall, there is a large vacant site visible. Originally there were a number of warehouses here, including the offices of Blacklock's, who published Bradshaw's railway timetables. The warehouses were demolished to make way for modern office buildings in a scheme which also incorporated the pedestrianisation of Brazennose Street and the creation of Lincoln Square. It is also possible to see the 'Hidden Gem', otherwise known as St Mary's, Mulberry Street. This Catholic church was opened in 1794 and rebuilt in 1844. It was the second Catholic church to be opened in Manchester.

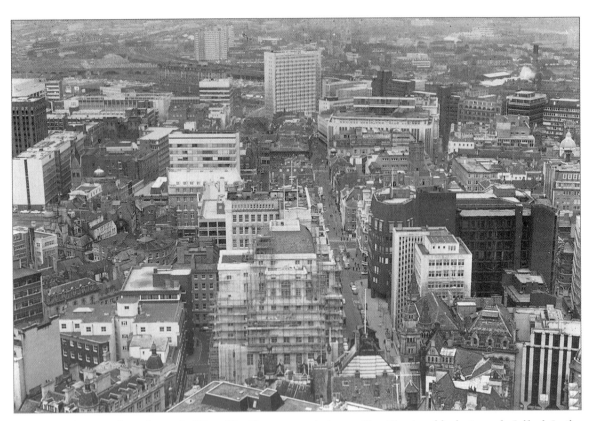

This particular view from the roof of Piccadilly Plaza concentrates on King Street and looks towards Salford. In the foreground, surrounded by scaffolding, is Lutyens' Midland Bank, a steel frame encased in white Portland stone, completed in 1929. Partially hidden behind the bank is Harry Fairhurst's 1926 building for the Manchester Ship Canal Co. On the opposite side of King Street, across the road from the Midland Bank, the upper part of the Reform Club is visible, completed in 1871 to designs by Edward Salomons. The structure dominating the right-hand side of this photograph is the black stone-clad NatWest Building completed in the 1960s on the site of the District Bank, which had been erected over the site of the York Hotel, where the Anti-Corn Law League held its earliest meeting. Peeping out from behind the NatWest building is the Edwardian baroque of Lloyds Bank, completed in 1912 on the site of Manchester's original Town Hall. Looking into the background, it is possible to see where the railway line from Liverpool to Manchester Exchange and Victoria stations joins with the line from Bolton and Preston, both built on viaducts to provide the trains with easy gradients in and out of Manchester.

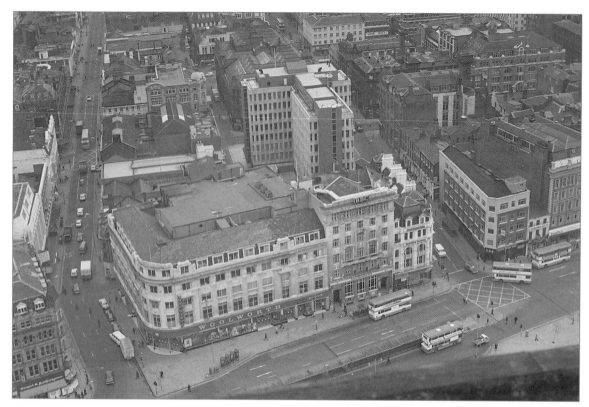

Looking down from the top of Piccadilly Plaza across Piccadilly, the Woolworth's store, which was opened in 1926 on the site of the Albion Hotel, can be seen. According to a French visitor to Manchester in the mid-nineteenth century, this hotel had a plain brick exterior, but its cuisine was among the best in Europe. Like other hotels in central Manchester in the nineteenth century, its manager was from continental Europe while guests came from many parts of the world. In the nineteenth century, many of the city's leading hotels were to be found in the vicinity of Piccadilly. Next door to Woolworth's was the home of the BBC for around forty years. The building, erected in the mid-1920s, had a bank at ground-floor level while the upper floors housed radio and television offices and studios. By the time the BBC moved from here to new premises in Chorlton-on-Medlock, its offices had expanded into the adjoining building to the right, which had been erected by Kitson's who were tailors. On the right-hand side of the photograph, there is a small building which appears to have been 'squashed' in between other buildings. In fact, the others were built around it. This small building is the last of the type which would have once graced Piccadilly. Many were occupied at the beginning of the nineteenth century by members of the medical profession because they were close to the Infirmary, which was located on the site of Piccadilly Gardens.

CHAPTER TWO

POSTERS

Until the middle of the twentieth century, advertising was mainly found in newspapers, magazines, on hoardings or on gable-end walls of houses and factories. Advertisers tried to catch the eye of the passer-by rather than his ears. Many posters were very striking, their image being more important than their words. Today, things are somewhat different. Commercial television and radio now bring advertisements more into the home and there is greater emphasis on the moving image, the spoken word, music and jingles. This chapter is not concerned with advertisements which appear in magazines, newspapers, on television or radio, but with the posters that were pasted on walls, gable ends and hoardings, adding colour to the streets of many towns and villages. Today, painted adverts on gable walls are no longer permitted but it is still possible to see the faded remains of some of them, especially where the gable wall has had a later building erected against it.

Although many posters and advertisements had relatively long lives, some were only short lived. Their importance lies in the immediacy of their message. Examples include notices or advertisements chalked on boards or walls or the newspaper billboard. Advertisements in this category can be changed quickly, but their objective is to encourage the public to enter the premises and purchase the product. Longer-lived advertisements and posters were those that were specially printed, stuck to walls and hoardings and could only be changed by sticking a new poster over them or being worn away by the weather.

Hand-bills and official notices can be traced back to the sixteenth and seventeenth centuries, but it was developments in printing in the nineteenth century that enabled the advertising industry to take advantage of the hoardings around building sites, gable-end walls and even special sites purchased on railway stations or on the sides of trams and buses. These advertisements show the gradual development of commercial pressure on people to buy goods which they might not otherwise have considered purchasing and also to make them aware of the existence of a particular shop or product.

Not all posters were used to advertise products or shops. The entertainment industry made extensive use of the medium, often outside theatres and music halls. In some cases, posters provided the only information available about what a particular place of entertainment was putting on. They were aimed at getting the general public inside the building and this was also true of posters outside churches, which have recently adopted a higher profile.

Although posters are generally associated with selling, some gave official information, such as details of election candidates or the compulsory purchase of buildings to enable redevelopment to take place. Sometimes posters and advertisements like the ones shown in this section are the only sources of information on a particular product or firm.

It is interesting to note that old advertisements, or rather the characters or images of these advertisements, occasionally reappear today. When this happens, one wonders whether the creator has been looking through old photographs for ideas.

As many posters were stuck on walls and hoardings, the photograph has enabled details of what they looked like and their message to be preserved for posterity. Many more posters have survived on photographs than in material collected by libraries and archive departments or in copies retained by printers for their own records. This chapter reveals some of the many posters on the walls, hoardings and gable ends of buildings in central Manchester which have survived through the medium of photography. Many of the photographs which are reproduced in other parts of the book also include advertisements and posters as part of the background.

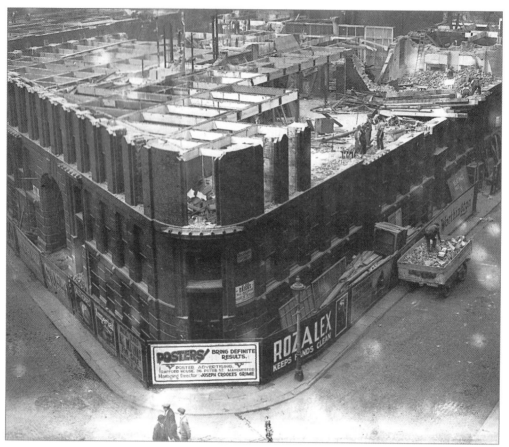

When the block of buildings bounded by Lloyd Street, Cooper Street and Mount Street were demolished in the early 1930s to make way for the Town Hall extension, one enterprising firm, Poster Advertising, took advantage of the hoardings around the site. Unfortunately, it is only possible to read some of the advertisements. The first, for the company responsible for the advertisements, proclaims 'Posters bring definite results'. Others are for Rozalex soap, Worthington's beers, Palethorpe's sausages, Symington's coffee and Imperial bricks. There is also a bill for a show or a film, but it is not possible to identify where this is being staged or shown. The building being demolished looks like a former warehouse with the large entrance gateway on the left, although there is no evidence of a yard. Perhaps the goods were lifted by hoist directly into the building.

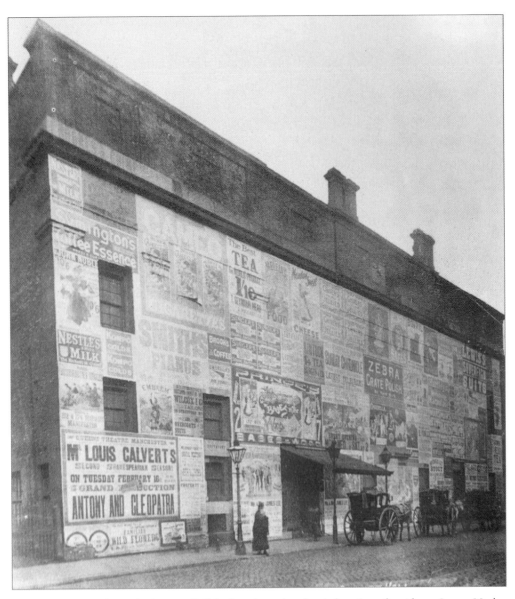

Although the Gentlemen's Concert Hall had an imposing front elevation, the side on Lower Mosley Street appears to have been a very plain brick wall with only three windows and possibly two doors. It was an ideal site for posters: not only could a large number be displayed, but it was near a major road junction and would be seen each day by hundreds of people passing along Oxford Street to Peter Street or entering central Manchester by way of Lower Mosley Street and from Central station. It is not known when the Gentlemen's Concert Society first allowed the wall to be used for posters, but it is possible that it was not until the 1880s or 1890s when the society was having difficulty in attracting audiences and raising money to maintain the building. This photograph was taken on 5 March 1897, just over twelve months before the building was closed and demolished to make way for the Midland Hotel. The wall includes advertisements for Nestlé's milk, Symington's coffee essence, Chiver's jellies, Zebra grate polish, Compo for colds, Seymour Mead's tea (which cost 1s 10d a pound!), Smith's pianos and Lewis's 'Sovereign' suites, as well as two posters for theatres' productions – *Babes in the Wood* at the Prince's Theatre on Oxford Road and *Antony and Cleopatra* at the Queen's Theatre on Bridge Street.

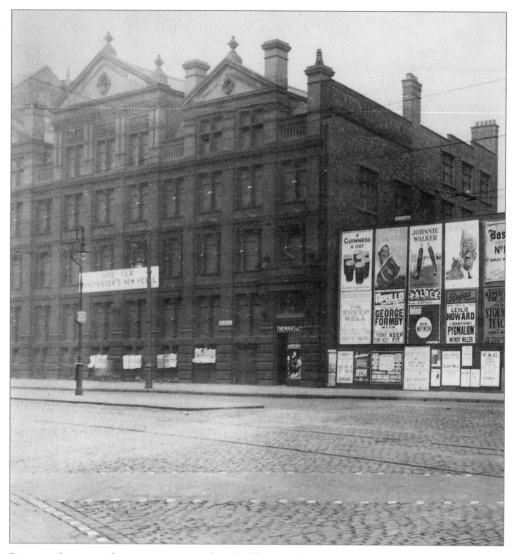

Between the wars, there was a proposal to build a new hotel at the bottom of the approach to London Road (now Piccadilly) station on the site now occupied by the Rodwell Tower. The notice on the warehouse in this picture from the 1930s warns of the development. It looks as though only the ground floor of the warehouse was still occupied with Themans, who were tobacconists, while on the first and second floors there appear to be lights in the windows, suggesting that this part of the building was still in use. The advertising hoarding conceals the Rochdale Canal as it passes under Piccadilly, where there was a small wharf which serviced the warehouse and buildings behind. However, the most striking thing about the photograph, other than the lack of traffic on what was, and still is, a very busy road, is the posters. Among them are several for places of entertainment including Belle Vue Circus, George Formby at the Apollo in Ardwick, *Dick Whittington* at the Palace Theatre, *The Lady Vanishes* at the Deansgate cinema, Vivien Leigh and Charles Laughton starring in *St Martin's Lane*, *The Saint* at the Paramount (now the Odeon) on Oxford Street and *This Way Please* at the Hulme Hippodrome. The adverts include several for alcoholic drinks such as Guinness, Johnny Walker, Bass No. 1 Barley Wine, Threlfalls Mild Ale and Mackeson's stout, while others encourage the observant reader to consider purchasing Atora suet, Bovril and Mazda light bulbs.

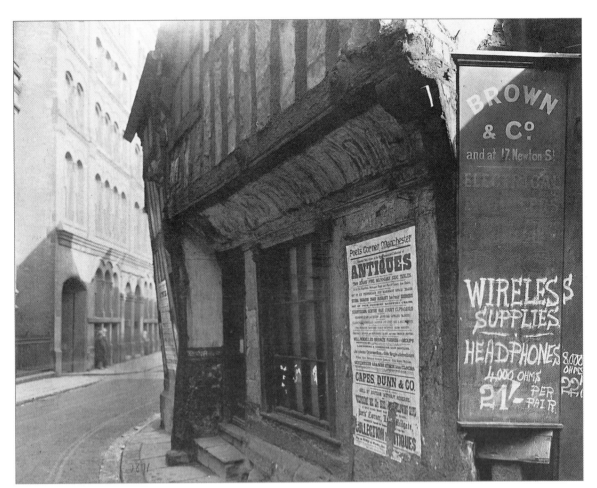

Sometimes notices or advertisements are very ephemeral – merely chalked on a board, with the result that they are easily removed either by individuals or by the weather. This photograph was taken late in 1922 or early in 1923 and shows the former Sun Inn at Poet's Corner on Long Millgate where the photographer has captured two different types of poster. The most obvious one, and the easiest to read, is chalked on a former shop sign for the company which was located there. It is for 'wireless supplies' and dates from the days of the 'cat's whisker', when broadcasting was still in its infancy. It is possible that at this time Manchester was still known by its call-sign '2ZY' and was still broadcasting from Trafford Park. The other poster is of the more traditional type and relates to the sale of antiques; a close examination reveals that the antiques are furniture and that the sale includes seventeen eight-day grandfather clocks, six Chippendale mahogany chairs and Lancashire oak settles. However, more interesting is the wording which appears just below 'Capes, Dunn & Co.', which indicates that the building itself was being sold at the same time 'without reserve', on Wednesday 13 December 1922. The Sun Inn was demolished shortly after it was sold and central Manchester lost one of its oldest surviving buildings. A link with the city's literary past was severed for it was here in 1842 that a group of local poets used to meet and read their works. As a result, the bend on Long Millgate where the building was located had become known as Poet's Corner.

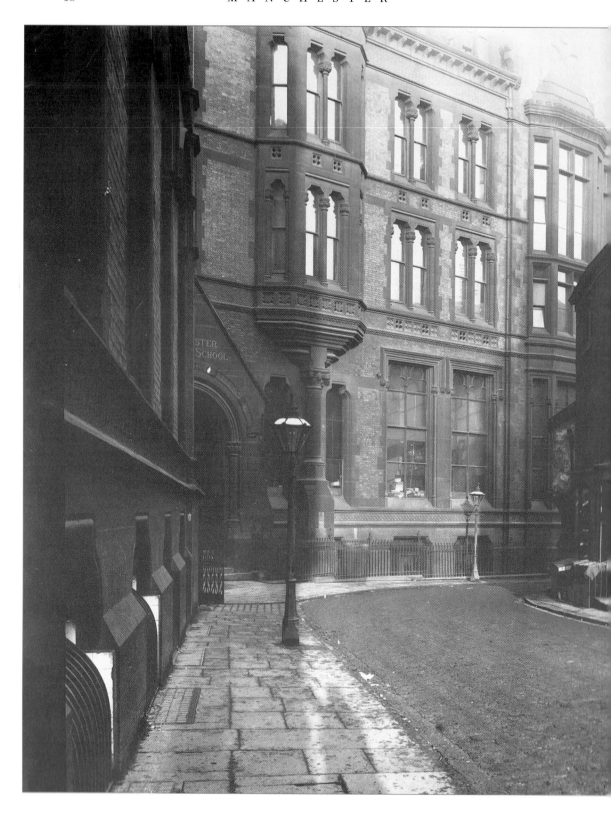

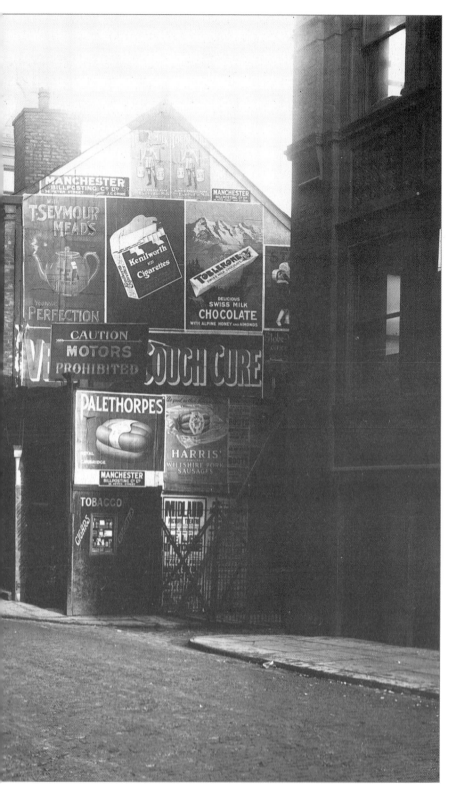

Long Millgate is one of the oldest streets in Manchester and still retains its medieval twists and turns. This photograph was taken looking towards Poet's Corner on 17 December 1921 and shows the building adjoining the former Sun Inn. The building seems to have been a bookshop but its gable wall had become a regular site for one of Manchester's bill posting companies. As well as advertisements for Ideal Milk (the poster at the top of the display), Palethorpe's sausages, Harris's Wiltshire sausages, Toblerone and Seymour Mead's tea, there is also a poster promoting Veno's cough mixture, which is partly obscured by a sign prohibiting motors from entering the back yard. Behind the gate is an advertisement for the Midland Picture Theatre. This was located in the former concert hall inside the Midland Hotel which had been converted into a cinema earlier in 1921.

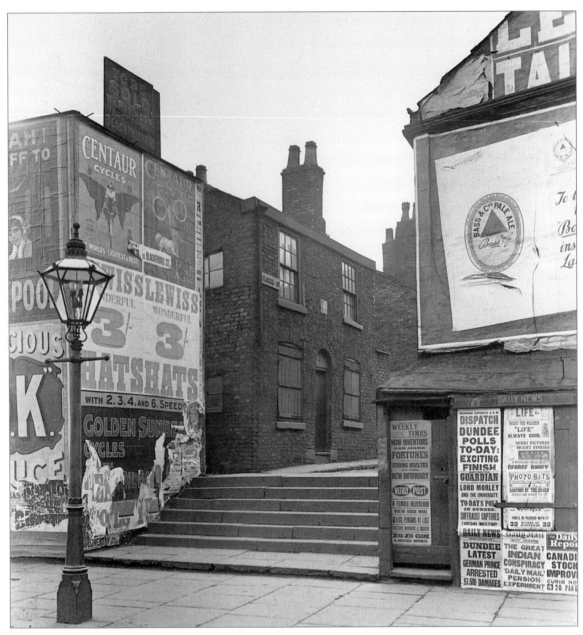

Although this photograph was taken in a residential part of Manchester, possibly the Hulme area, the advertisers have still made full use of all the available space to get their message across. There are adverts not only for bicycles such as Centaur and Golden Sunbeam, but also for Lewis's hats, for Blackpool as a holiday resort and for OK Sauce. On the right can be seen some of the many newsprint billboard posters which were published each week. These have been pasted to the walls and doors of a small newsagent's kiosk, presumably to attract customers. At the very top of the left-hand hoarding is a notice advertising the fact that the site was for sale and that the auctioneers were W.H. Robinson's. The latter was established in the mid-nineteenth century and was one of Manchester's leading property auctioneers. Although the illustration is not dated, there is a clue on one of the newspaper billboards which refers to 'Daily Mail Pension experiment'; this suggests that the photograph might have been taken in about 1907. Mention is also made of suffragettes taking over a Liberal Party meeting. The photograph shows the way in which posters were stuck one on top of another; when they began to peel off, the old ones were exposed again.

Newspapers were often distributed by sellers walking the streets.
In the early twentieth century, there were a great many of these,
but now the numbers are declining and they tend to have fixed
pitches or sites. This particular seller is carrying a poster
encouraging people to purchase the paper with news of the relief
of Ladysmith in 1900 during the Boer War.

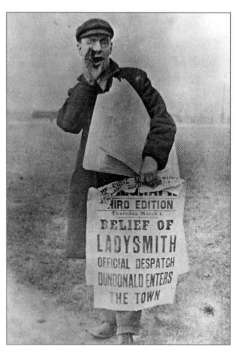

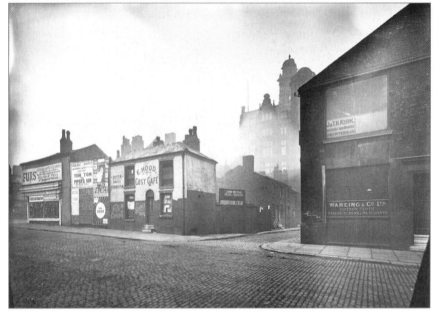

This collection of posters and shop adverts from about 1921 or 1922 was to be found on Charles Street. The photograph clearly shows how every available site was used for advertising in the days when posters were one of the main ways of getting a message across. According to local trade directories, the shop selling furs was occupied by an H.A. Blaiwais and was only there for a short time before the building was demolished to make way for a new development. Previously, the premises had been occupied for many years by a firm of clothiers trading as the Oxford Clothing Company.

According to the directory of 1922, E. Hood of the Cosy Café in the picture was Evelyn Hood, who was a fried fish dealer: the café is first recorded in 1921. In 1923 there are no entries for the Cosy Café, which had been open for almost twelve hours a day to serve those who lived and worked in the area. Earlier directories list the previous occupier as a Sarah Ann Whalley, who was a shopkeeper. The adverts to the left of Cosy Café are mainly for entertainment, including *Tom Tom the Piper's Son* which was on at the Opera House. It appears that this was the Christmas pantomime, but the fact that the Palace Theatre was advertising *Mona Vivian* suggests that the pantomime season was over and that the opera house's poster had not been replaced. The very dark poster is for the Majestic, but it is not possible to make out who was appearing there at this time.

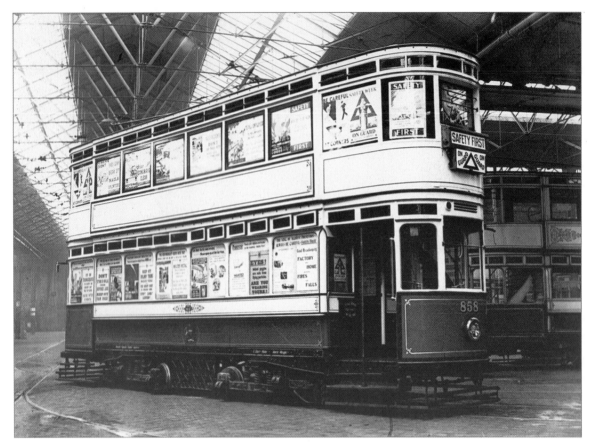

During the interwar years, the number of motor vehicles on the roads increased dramatically, as did their speed. In order to make the general public aware of the dangers of motor traffic and encourage them to be more road safety conscious, Manchester City Council came up with the idea of a mobile advert. It decided to use one of its trams and covered it with road safety adverts. Whether the tram remained parked in one place or moved throughout the city is not clear as it was photographed in the depot. The tram itself was built in the early 1920s and was capable of carrying seventy-eight passengers in normal service.

Opposite: One of the perennial problems facing businesses which occupy only part of a building or are located in a court is ensuring that customers know where to find them. Some businesses overcame this difficulty by placing their name on a board at the entrance to the court or building so that customers knew who was where. This collection of nameboards was located at the Corporation Street end of Bull's Head Court and represented an interesting array of businesses. The first shop on the left of the illustration does not really need any written text to tell the passer-by what it offered – it was a locksmith's as the key clearly shows. Further along the court another three-dimensional advert can be seen – a large pair of spectacles which were used by an optician to advertise his presence. At the far end of the court, just beyond the figure, is the corner of the Wellington Inn, located in the Market Place.

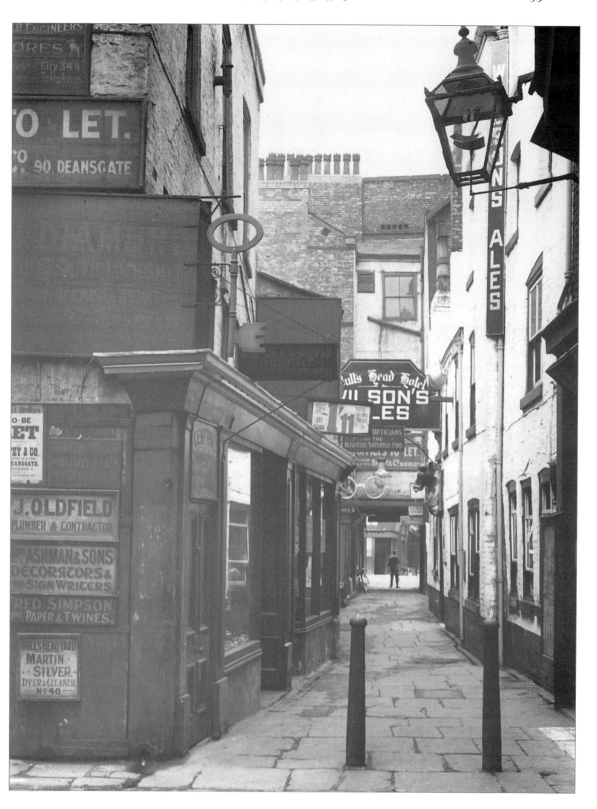

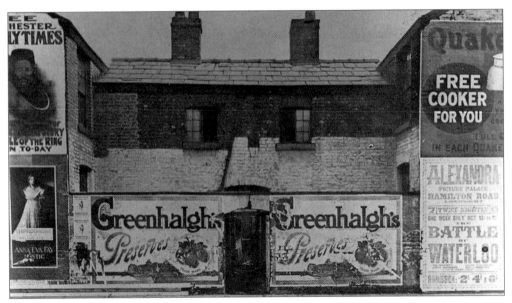

This photograph clearly shows how poster companies used every available space to advertise their clients' products. Apart from two well-known firms – Quaker Oats and Greenhalgh's Preserves – there are posters for the *Manchester Weekly Times*, which ceased publication in 1922, and for two places of entertainment, the Alexandra on Hamilton Road in Longsight and the Hippodrome, which was on Oxford Street in central Manchester. The Alexandra's poster gives a date, 13 October, but no year. Assuming that the film opened on Monday evening, the year the photograph was taken would have been 1913 or 1919.

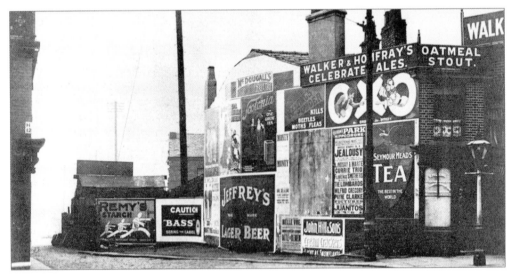

Posters were not only to be found in the centre of towns. Vacant sites or gable walls in the suburban areas were also very much favoured. This collection of posters was to be found on Factory Lane in Blackley in 1907 and brightened up a rather dreary corner. The products advertised included well-known brands such as Oxo, McDougall's flour, Seymour Mead's tea, Bass beer and the products of one of Manchester's local brewery's, Walker & Homfray's. However, others are equally interesting such as John Hill & Sons' cream crackers, Remy's starch and a powder which killed all types of insects. As well as the advertisements for products, there are also two for places of entertainment: Belle Vue and Queen's Park Hippodrome. (*Victorian Society*)

SUBURBAN MANCHESTER

Until 1838, the name 'Manchester' was applied only to the centre of the present-day city. The surrounding areas were independent townships within the parish of Manchester and as such were responsible for their own administration, if any proper administration existed. However, as conditions in the central area deteriorated, those who could afford it began to move to more pleasant surroundings on the edge of the town. Each of the new townships was centred on a village or hamlet which gave it its name and these have been preserved today as the titles of districts. Although most people regard suburbs as residential areas, it should be remembered that suburban areas can be divided into three general groups: residential, industrial and those where there is a mixture of both industrial and residential premises.

The earliest suburban development in Manchester appears to have taken place in the St John's Street/Byrom Street area in the 1770s, but by the beginning of the nineteenth century, the trend was starting to move into surrounding townships like Ardwick and Cheetham. These areas were within easy reach of central Manchester where the factories, warehouses and other business premises were located, yet far enough away to provide a rural setting for the new homes.

However, to the east, still within the township of Manchester, the industrial suburb of Ancoats, dominated by multi-storey mills on the banks of the Rochdale and Ashton Canals, developed in the late eighteenth and early nineteenth centuries. At the same time, the part of Chorlton-on-Medlock closest to Manchester also began to become an industrial area with the erection of Chorlton Mills on the banks of the River Medlock. Industrial suburbs were characterised by factories, mills and often poor quality housing.

Improvements in transport gave further impetus to the outward expansion of Manchester and the development of residential suburbs. In 1824, the first horse-drawn omnibus was introduced from Pendleton into Manchester. Shortly afterwards, other routes were developed to areas including Greenheys to the south. Throughout the nineteenth century horse bus, and later horse-drawn tram, routes expanded and fares fell making it easier for people to move away from the overcrowded central area. After 1851, the population of central Manchester began to fall, slowly at first, but at an accelerating rate. At the same time, the popularity of places like Rusholme, Levenshulme, Withington and Crumpsall as residential areas increased. Often it was the redevelopment of residential parts of the city centre that forced people to move. The poorest, who were often those most affected, moved only short distances into adjacent areas. Those already living just out of the city centre either stayed or moved a little further out. Often those who had moved into a new area from an adjacent one were often regarded as being of a lower social status and were therefore considered to be lowering the character of the

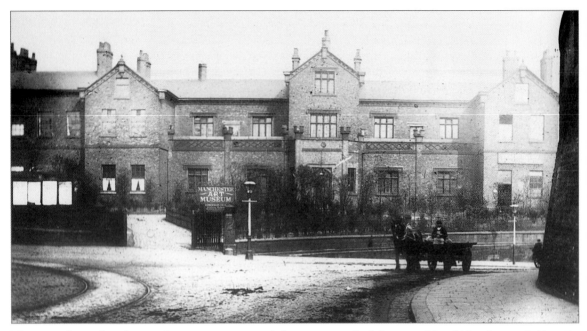

The area often referred to as Ancoats sweeps round the eastern end of the township of Manchester, linking the Rivers Irk and Medlock. It was never an independent township like Ardwick or Cheetham although technically it is not one of Manchester's suburbs either. For many centuries, one of the area's most important buildings was Ancoats Hall, was one of the homes of the Mosley family in the seventeenth century. The original half-timbered building was demolished in the early nineteenth century and replaced by the Georgian one shown in this late nineteenth-century photograph. The Mosleys ceased to use it in the late eighteenth century and sold it. During the nineteenth century the building was not only used for residential purposes. In the 1880s, it was converted into an art museum by Thomas Horsfall, who aimed to bring some culture and appreciation of the fine arts and countryside to the residents of this overcrowded edge of central Manchester. Eventually, after being used as a railwaymen's social centre for several years, the building was demolished because the land was required for a road improvement scheme.

area. Existing residents often moved on to a new area, creating a sort of ripple effect of movement outwards.

The industrial suburbs tended to be concentrated on the eastern side of Manchester. Richard Peacock of Beyer Peacock summed it up when he said that the reason why he chose Gorton for the Manchester, Sheffield & Lincolnshire Railway's works in the 1840s was that this was the first place where the land and the railway were at the same level, but also that the rates were lower, the land cheaper and that there was access to the skilled labour in nearby Manchester.

It was not until 1838 that the borough of Manchester was created, comprising the townships of Manchester, Hulme, Chorlton-on-Medlock, Ardwick and Cheetham. These latter areas provided Manchester with its first residential suburbs, but as the town grew, they became increasingly built up and the wealthier residents began to move away. Almost fifty years later, in 1885, the boundaries of the city were extended to include Rusholme, Harpurhey and Bradford, whose populations had been swelled by those who moved away from Manchester to live in more pleasant surroundings.

The next phase of Manchester's expansion took place in 1890 when Clayton, Crumpsall, Moston, Blackley, Openshaw and part of Gorton joined the city. The

beginning of the twentieth century saw further expansion. In 1904, Withington, Didsbury, Chorlton-cum-Hardy and Moss Side became part of Manchester, although in the case of Moss Side, there was a strenuous rear-guard campaign to try to prevent the inevitable. Expansion into the south-east part of Lancashire was completed in 1909 when Levenshulme and West Gorton became part of the city. However, Manchester still needed more space, especially with the advent of slum clearance programmes between the wars. In 1931, a portion of north Cheshire was taken over to form Wythenshawe, which was to be a new town for those displaced by slum clearance in areas like Hulme, Ancoats and Ardwick.

This selection of photographs does not cover all the suburbs of Manchester – space does not permit. It should also be remembered that there are photographs of some of the suburbs in other sections of the book. For example, there are images of firms like Clayton Aniline, which is in Clayton, and Beyer Peacock, located in Gorton, in the section on industry, while others appear in the section covering recreation.

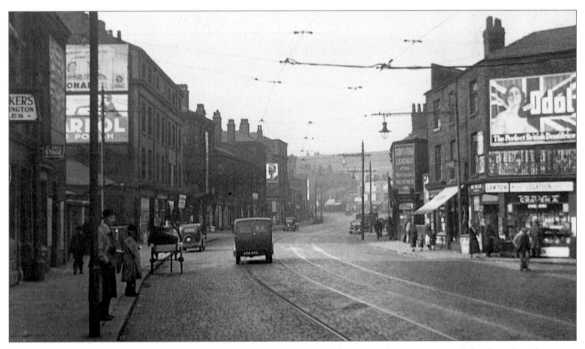

The railway line linking London Road station with Oxford Road station forms a sort of dividing line between central Manchester and the surrounding inner-city suburbs. Until the construction of the Mancunian Way in the late 1960s and early 1970s, this was very noticeable on London Road. To the north of the railway were large, impressive buildings while to the south the road was lined with small shops, some of which had living accommodation on the upper floors. This photograph of London Road, taken in the early 1950s, shows the spot where London Road, central Manchester, becomes London Road, Ardwick, the boundary being the River Medlock, the bridge over which the van in the photograph is crossing. In 1939, the shops on this section of London Road were selling everything from dog food to wireless parts, from confectionery to baby clothes. There was even a tattoo artist recorded in the directory for that year. After the war, the shops were less varied, but in 1951, there were still stores selling baby clothes, surgical rubber goods, radios, tyres, bar fittings, confectionery and newspapers. Other businesses found in this area included a butcher, a wood carver and a hairdresser. In the background is the roof of London Road station. All this area has since been demolished and is now covered by the Mancunian Way and its associated roads.

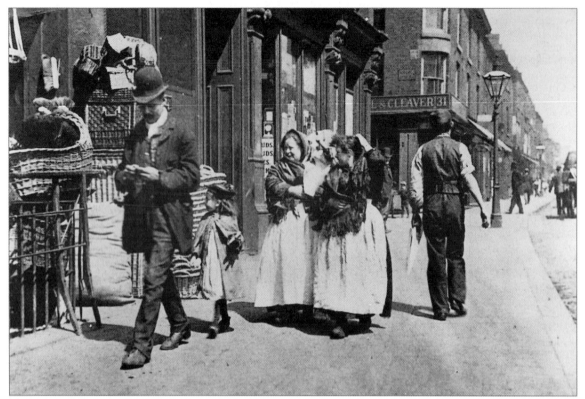

The boundary between central Manchester and Ancoats is difficult to define. However, it is often assumed that Great Ancoats Street/Swan Street is a kind of dividing line between the two. This photograph, taken between 1893 and 1898, reveals the view along Rochdale Road towards Collyhurst and Harpurhey, and shows the junction with Angel Street which led down to Angel Meadow where living conditions left much to be desired. The shop on the corner of Angel Street and Rochdale Road is Steel & Cleaver, butcher, which occupied 31 Rochdale Road between 1893 and 1898. Previously the premises had been used for a chemist's or druggist's shop. After Steel & Cleaver left, the building continued to be used as a butcher's for a number of years before the area was demolished as part of Manchester's slum clearance programme. The family are passing in front of a wholesale jewellers while the secondhand shop which the man is passing also housed an insurance company.

Opposite, bottom: About 4 miles east of central Manchester lies Charlestown, which was described in 1890 as a 'picturesque and quaint little village' close to the Rochdale Road at Blackley. Despite its proximity to Manchester and the industrialised valley of the River Medlock, Charlestown retained its rural appearance and atmosphere into the twentieth century. One of the area's most prominent residents in the nineteenth century was the radical author Samuel Bamford, who is said to have written many of his most important works here, including *Passages in the life of a radical*, *Walks in South Lancashire* and a glossary of Lancashire words and phrases. When Bamford moved to Charlestown, the area was still relatively free from pollution and considerably quieter than his former home in Middleton, which was a rapidly growing mill town. At Charlestown, Bamford ran the local post office. His garden was reported to be 'neat . . . laid out with daisies, wallflowers, sweet pink, white rock, polyanthus, and rose trees, and a beautiful woodbine . . . entwined over the door'. This photograph, taken in the 1890s, shows the rural nature of the community.

In the nineteenth and early twentieth centuries, the temperance movement was very strong in Manchester, especially in the Methodist Church and its various branches. This photograph shows Chancery Lane Wesleyan School and Mission in Ardwick. According to Les Sutton in his unpublished work on Ardwick, this chapel could trace its origins back to the late eighteenth century when a Sunday school was established in the area. The chapel prospered in the nineteenth century attracting a large congregation of local people. In 1879, it was decided to replace the original chapel with a larger one, which opened in 1880. Chancery Lane Sunday School had a sick club for teachers and scholars as early as 1821 while Bank Meadow School, which

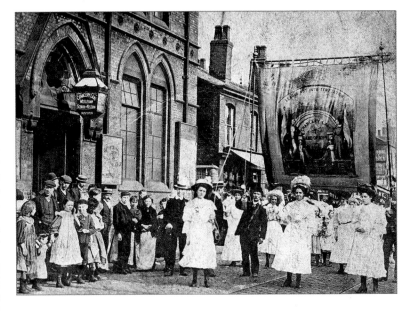

eventually merged with Chancery Lane's school, had its own sick and burial society. The latter's work was taken over by the temperance movement. This photograph, believed to have been taken in the early twentieth century, shows what must be a Sunday school procession, possibly during Whit Week when the scholars and teachers paraded around the district in their best clothes with Sunday school and temperance banners. The clean white clothes of those taking part in the procession contrast with the dress of the bystanders on the pavement, some of whom may have been members of the church. The building was demolished in the mid-1950s as the area was gradually redeveloped.

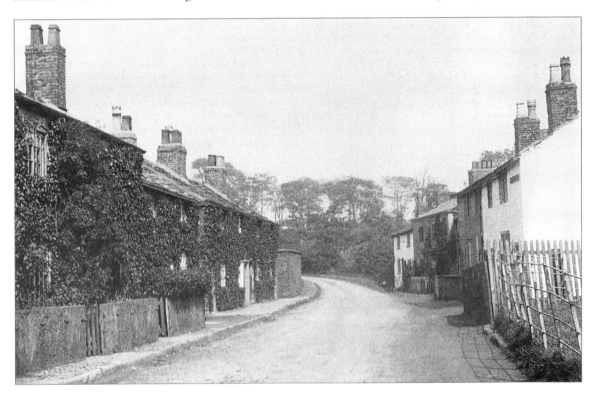

In the Middle Ages, Blackley was part of a deer park which belonged to the lords of the manor of Manchester. Whether it included the large open space acquired by Manchester City Council in 1894 and known as Boggart Hole Clough is not known, but it is more than likely that it did as records refer to deer leaps in the area. The land on which Boggart Hole Clough was created included a stream with steep sides which was of little use for development purposes. The land acquired in 1894 provided the parks department with an ideal spot for growing plants which could not be cultivated elsewhere in the city because of atmospheric pollution. As well as pleasant walks, the department also created a boating lake, which was said to provide views across the Irk valley towards the Pennines and to be above the pollution which often blanketed the area. This photograph, which may have started life as a family snapshot, shows 'Reg and Meg' in a rowing boat, possibly during the interwar years.

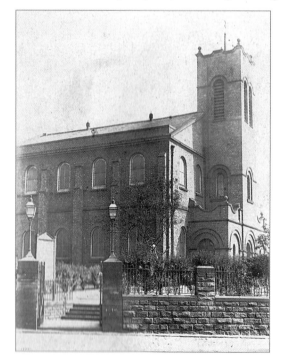

As Manchester expanded in the late eighteenth century, the number of people living in the surrounding townships also increased, although more slowly than in the centre of the city. For those living at the northern end of the township of Cheetham, it was a long walk into Manchester to attend the nearest Church of England place of worship, which was the Collegiate Church. Consequently, the church authorities were prepared to look favourably on proposals to erect new churches in outlying areas. Technically, new churches were chapels and not parish churches in their own right although they performed the functions of a parish church. In 1790, Charles Ethelson proposed that a new church be built at the northern end of Cheetham, close to its boundary with Crumpsall. The new church, shown here in about 1918, was consecrated in July 1794 and dedicated to St Mark. The Ethelson family continued to provide the clergy for St Mark's Church until 1872 when Revd Hart Ethelson died. When the church was built, it was a simple brick building: the tower was not added until 1894. It was surrounded by what were described as 'merchants' or gentlemen's villas'. Some of these properties still remain although they have been converted into offices and shops. The church itself is hidden from the main road and in 2000 its future is in doubt as a viable place of worship.

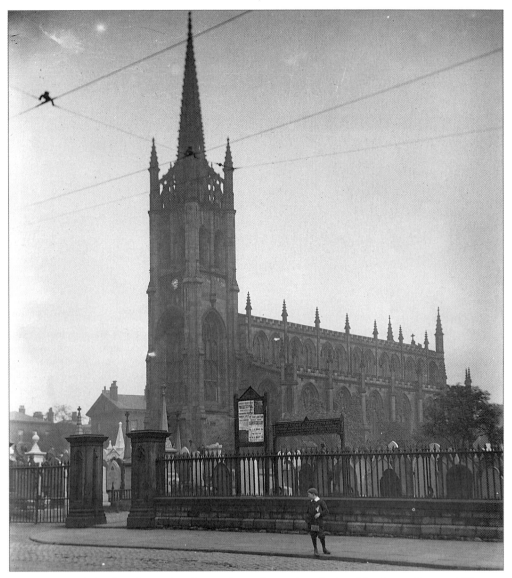

In 1890, St Luke's Church on Cheetham Hill Road was described in *Manchester Faces and Places* as being 'surrounded by a forest of gravestones' and that 'with its fine crocketted spire and pinnacles', it was a 'noteworthy object in the Cheetham Hill district'. This photograph, taken in the early twentieth century, shows how impressive the church appeared from the main road. Built at a cost of £23,000, it was designed by V.W. Atkinson and is said to have been modelled on Louth parish church, Lincolnshire. It was consecrated in 1839. The organ, built by Hill's of London, was said to have been one of the finest in Manchester. When it was inaugurated in 1840, St Luke's choir was augmented by members from the choirs of Westminster Abbey, St Paul's Cathedral and the Chapel Royal. When Felix Mendelsohn visited Manchester to conduct 'Elijah' at the Gentlemen's Concert Hall Society in April 1847, he stayed with Charles Souchay and visited St Luke's Church where he spent 1½ hours playing the organ. At the time of its construction St Luke's was a fashionable church in a select residential area, but as the nineteenth century progressed, the merchants and businessmen moved further away and the open fields which surrounded St Luke's were built on. Today, only the lower part of the tower remains – the church developed dry-rot in the 1970s and had to be demolished. The organ was removed and taken to St John's in Radcliffe.

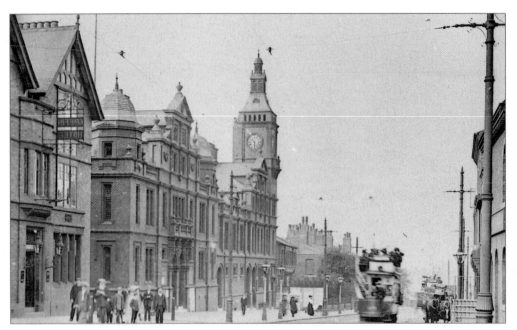

In 1838, the township of Cheetham was incorporated in the new borough of Manchester. At that time it was becoming a residential area for merchants and businessmen as it lay only a short distance away from both Manchester and Salford and had pleasant views across the Irk valley to the Pennines. This early twentieth-century photograph shows Cheetham Hill Road (originally known as York Street). In the mid-nineteenth century several imposing buildings were built along the road; these included the Assembly Rooms, offices for the Prestwich Board of Guardians, Cheetham Public Hall and Baths, erected in the 1850s (the tower of which can be seen in the photograph), and several synagogues, for Cheetham Hill was the centre for Manchester jewry. This photograph shows the junction of Cheetham Hill Road and Heath Street, looking towards Manchester. In 1876, *City Lantern* pointed out that the residents of Cheetham Hill had no need to go into Manchester to shop as everything they might require was available there – except banks and pawnbrokers!

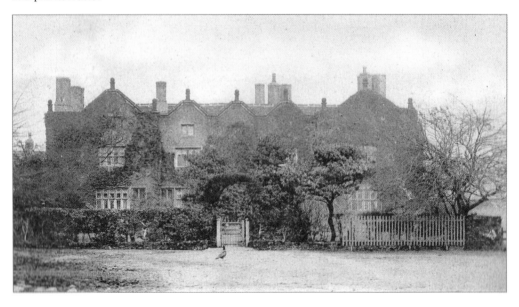

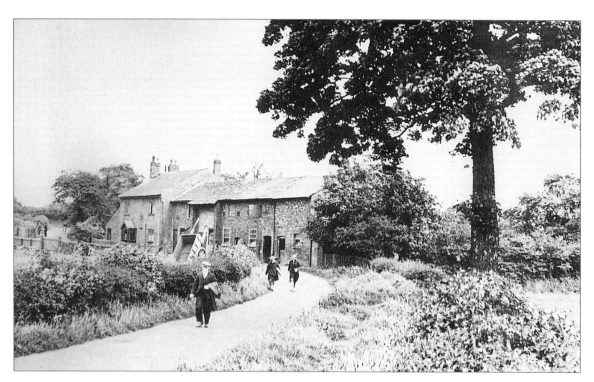

The River Mersey formed part of the southern boundary of the city of Manchester between 1904 and 1931 and, with its wide flood plain and tendency to burst its banks, formed a natural barrier against development – it still does today. Attempts to reduce the effect of flooding and make the land economically viable were made in the Middle Ages when the first embankments were constructed to contain the river. However, flooding continued and even today, with the original embankments raised and reinforced, floods still happen along the Mersey in Manchester, especially in the Northendon and Didsbury areas. As a result, development on the Mersey flood plain has been restricted to a few farms, an inn and, in the late nineteenth century, Withington Local Board of Health's sewage facilities in Chorlton. The farms and cottages built close to the Mersey tended to be on the river terrace, above the usual flood level. One of these was Hardy Lane Farm, shown here in 1931 when Hardy Lane was a pleasant rural road. Hardy Lane itself led to Jackson's Bridge and the Bridge Inn, which was the only place to cross the river in this area.

Opposite, bottom: Between 1596 and 1845 the Mosley family were Lords of the Manor of Manchester. The first Mosley to hold the position was Sir Nicholas, who purchased it for £3,500 from John Lacy of London. Nicholas was a member of the City of London and became Lord Mayor of London in 1599. The family, however, was not new to the Manchester area as Jenkyn Mosley, one of Nicholas's ancestors, is recorded as having lived at Hough End Hall in about 1465. At that time it was probably a black-and-white, half-timbered house, but when Nicholas took up residence, he had the hall rebuilt in brick. It is said that he used brick because he did not like living in timber-framed buildings, having lived in brick ones in London. The new building, shown here in about 1906, was described in the early twentieth century as 'a charming, well-proportioned example of one of the most interesting phases of English architecture', although by the time this was written, the building had been altered from its original state and portions of it had been rebuilt. The brick walls, constructed on a thick stone plinth, were said to be 2ft 1in thick at ground-floor level. The Mosleys continued to live at Hough End until 1720 when it appears to have become a farmhouse, which it remained to the end of the nineteenth century. At various times, its existence has been threatened by road schemes, but nothing has ever come of them. In 1927, it was suggested that the building, which was gradually deteriorating, should be restored and converted into a hall of residence, leased to a society or turned into an art gallery. Ten years later, the cost of restoring the building was put at between £2,000 and £6,000, but little was done until the 1970s when it was converted into a restaurant. Today, the hall is hidden from view by a modern office block.

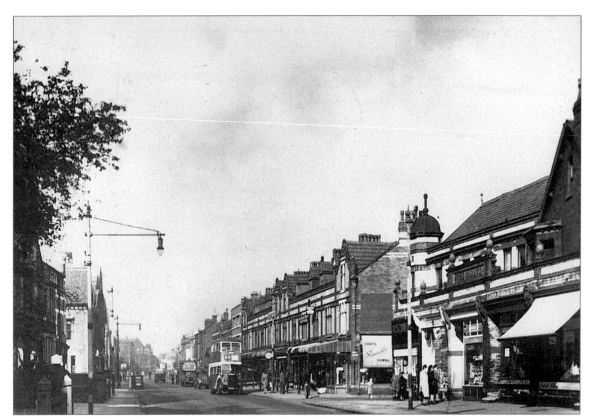

During the last seventy-five years the part of Barlow Moor Road which is in the centre of Chorlton village has changed little. This picture was taken in the early 1950s and shows the portion of the road between Wallworth Avenue (later renamed Needham Avenue) and Wilbraham Road, which was formerly known as Pemberton Arcade. (By the 1930s, this name had been dropped from the directories.) Over the years, the type of shops here changed. In 1906, they included a chemist, a photographer, a fruiterer, a draper, a confectioner, butcher, provision merchant and a hairdresser. Thirty years later, there was a wine merchant, paint merchant, a milliner, a grocer, a bootmaker, a hairdresser and an outfitters occupying the range of shops shown in the picture. By the beginning of the 1950s, many of the stores established before the war were still trading there, although they had been joined by other firms such as Singer Sewing Machines and Shropshire Farm Produce, which was a grocer. (*J. Ryan*)

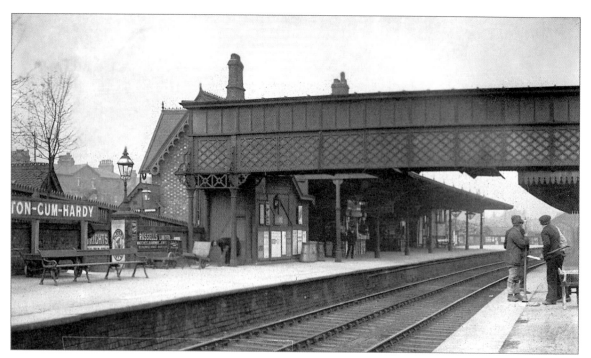

The first station after leaving Manchester Central for Stockport and the Peak District was Chorlton, located close to Wilbraham Road and now the site of a supermarket. The station was opened in 1880 when the line between Marple, Stockport Tiviot Dale, Heaton Mersey and Manchester Central was completed by the Midland Railway company. The arrival of the railway in the area resulted in new development, encouraging a growing number of office workers to consider moving to suburbs like Chorlton-cum-Hardy. The train service provided a quiet and efficient means of commuting to work each day and enabled people to enjoy the benefits of living in a leafy area, away from the pollution of central Manchester. Like other stations on the line, Chorlton had its own bookstall, which can just be seen beyond the footbridge, enabling passengers to purchase their morning paper while waiting for their train. As well as trains to Manchester and Stockport, Chorlton station also had a few services that went via Alexandra Park, Fallowfield and Levenshulme to Fairfield junction on the Manchester, Sheffield & Lincolnshire Railway's line between Manchester and Sheffield. This line was never a success as it was a much slower route for those from Levenshulme and Fairfield who wanted to get into Manchester. However, it was a useful line for freight traffic and passenger services using the Cheshire Lines routes to the west of Manchester to gain access to services that ran eastwards out of Manchester and vice versa. Possibly the best known of these was the one that ran from Liverpool via Manchester to Harwich to connect with the night sailing to the Hook of Holland. (*J. Ryan*)

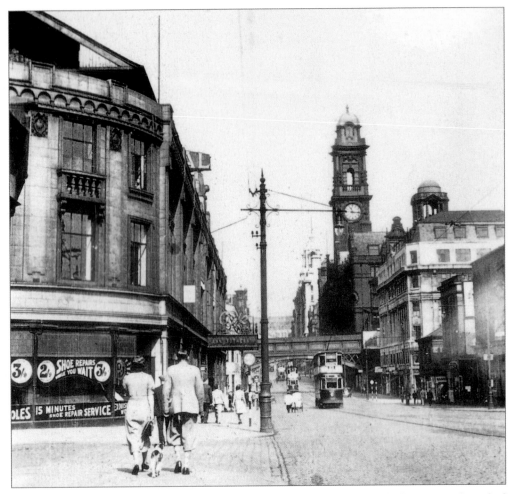

This view shows the beginning of Oxford Road in Chorton-on-Medlock, looking towards Oxford Street and St Peter's Square in about 1930. Originally, the whole length of the road from St Peter's Square to Hathersage Road (formerly High Street) was known as Oxford Street, but in about 1886, it was decided to rename the section through Chorlton-on-Medlock as Oxford Road, the change taking effect from the railway bridge in the picture. The bridge was opened in 1849 and carried the Manchester, South Junction & Altrincham railway line from London Road station to Oxford Road station and then on to either Altrincham or Ordsall Junction. Just in front of the bridge, the road crosses the River Medlock, which was the boundary between the townships of Manchester and Chorlton-on-Medlock and could be said to mark the southern edge of what is called central Manchester today. The road on the left of the picture leads into an area which was notorious in the mid-nineteenth century for its poor housing conditions – Little Ireland. It was built on low-lying land on the banks of the river and the cholera epidemic of 1832 caused many deaths in the area. The white building on the right was known as Shell-Mex House and was built in the late 1920s, replacing a row of shops. The BSA shops are now the BBC's regional headquarters and studios. The trams in the photograph were on cross-town routes. In 1930, service no. 13 ran between Hightown and either Brook's Bar, Victoria Park or Chorlton (Chorlton-cum-Hardy), while the no. 27 ran from Old Trafford to Piccadilly, Clayton, Edge Lane or Droylsden. Tram no. 450 had been introduced during 1901/2 and was originally open topped, but in 1905, a cover was fitted and later, during 1922/3, it was rebuilt and improved.

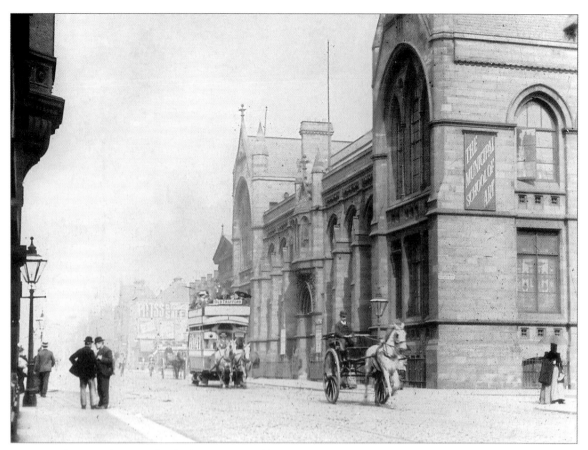

In 1838, the Manchester School of Art was established by the Royal Manchester Institution in the art gallery which it had built on Mosley Street (now the Manchester City Art Gallery). The Art Gallery remained the School of Art's home until 1881 when it was decided that because of rising student numbers and the fact that the Royal Manchester Institution was considering donating the art gallery to the City Council, the School of Art should move to separate premises. A site was acquired at All Saints, adjacent to Chorlton Town Hall, and G.T. Redmayne was commissioned to design the new building, which was opened by the Earl of Derby. In 1898, the school was extended to provide a gallery where students' work could be displayed. Today, the buildings form part of Manchester Metropolitan University. This photograph was taken in about 1895 and shows the original building fronting Stretford Road. To the left of the School of Art was Chorlton Town Hall and a small portion of its front portico can be seen above the tram. Chorlton Town Hall was designed by Richard Lane and completed in about 1830/1 for the Chorlton police commissioners. The 5th Pan-Africa Congress took place in the Town Hall in 1945 and was attended by future leaders of African states including Jomo Kenyatta and Kwane Nkrumah. The former Town Hall was demolished in the mid-1970s although the façade was incorporated into a new building on the site. On the left of the photograph by the lamppost the offices of the Chorlton Poor Law Union can be seen. Its workhouse was originally located in Hulme, but moved to Withington in the 1850s.

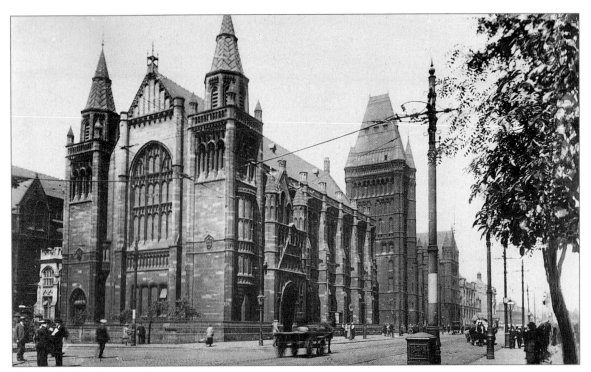

When John Owens died in 1845, he left over £168,000 of which £98,000 was given to establish a place of higher education where no account was taken of the religion of either students or staff, in contrast to some other institutions where membership of the Church of England was a criterion for admission. The only criterion that Owens did impose was that priority should be given to those who came from Manchester or whose parents came from the town, but it was never necessary to invoke this means of deciding who to admit. Owens' money was not spent on buildings, but on funding lectureships and professorial chairs. Owens College, as it became known, was established in 1851 in a building on Quay Street that had been owned by Richard Cobden. Over the next twenty years, the number of students and the reputation of the college grew, with the result that it became necessary to find alternative premises. In 1873, the college moved from central Manchester to a new site in Chorlton-on-Medlock where new buildings designed by Alfred Waterhouse were erected. Gradually the size of the college increased. New buildings were added, including the Manchester Museum and the Whitworth Hall, which is the main building in this picture. Up to 1880 Owens College had to award London University degrees, but in that year it became the first college in a federal university. Eventually, in 1904, the federal university was broken up and the constituent colleges, including Manchester, formed independent universities. Today, Manchester University extends over a large area; modern buildings were added during the middle quarter of the twentieth century.

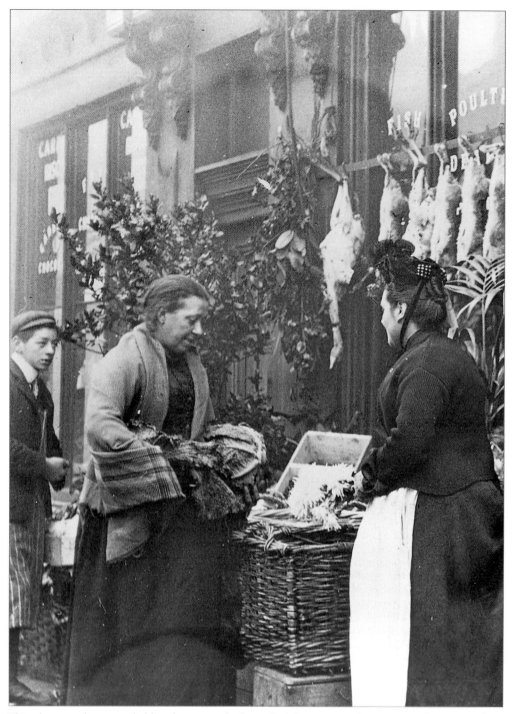

This photograph was probably taken towards the end of the nineteenth century and seems to show one of the suburbs of the city where there was a demand for fresh fish, poultry and game. The photograph must have been taken before Christmas because there are geese hanging up in front of the window and bunches of holly on either side of the door. The shop also appears to have sold vegetables. The lad on the left may have been a delivery boy for the shop.

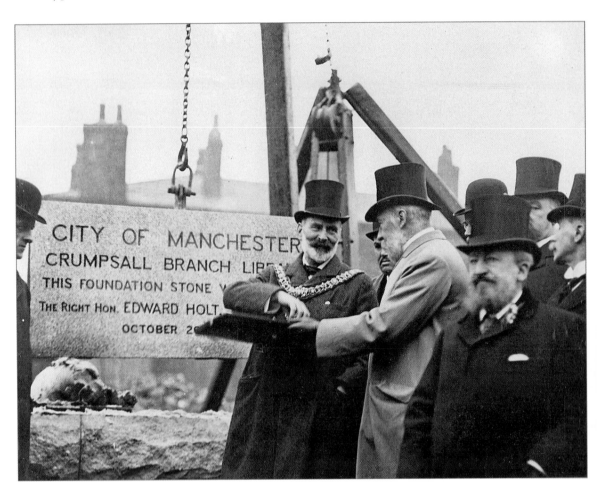

In 1857, Manchester Free Libraries began a programme of extending into the suburban areas of the city. Initially, three branches were opened – in Ardwick, at New Cross and in Hulme – and proved to be very popular with the local residents. For instance, in Hulme the demand for books was such that the library outgrew its original premises and had to move to larger ones until a purpose-built library could be erected next to Hulme Town Hall on Stretford Road. Other branches followed in areas including Chorlton-on-Medlock and Cheetham, the aim being to ensure that all Manchester's citizens were within easy reach of a library. In addition to lending facilities, many libraries also included a newsroom and even children's rooms. When Manchester expanded its boundaries and took over formerly independent districts, a policy of extending library provision into these areas was implemented. Initially, these libraries tended to be in temporary premises, but gradually purpose-built facilities were constructed to meet the needs of local communities. Crumpsall Library opened in temporary premises in 1897, but in 1911 moved to a new branch building on Cheetham Hill Road, close to the local shopping centre. This photograph was taken at the laying of the foundation stone on 20 October 1909 by Edward Holt, Lord Mayor of Manchester. The new library not only included lending facilities, but also a large room in the basement which was eventually used for adult education classes.

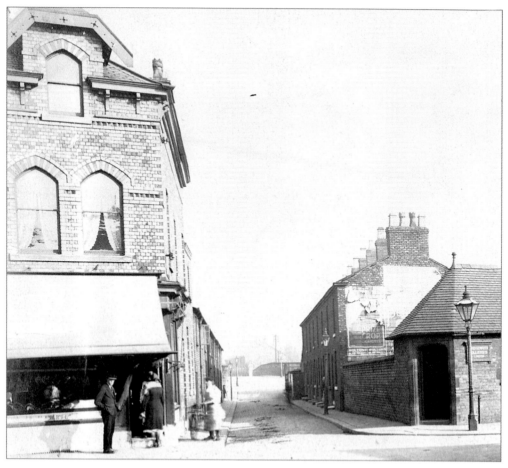

Didsbury, situated close to several crossing points on the River Mersey, was probably founded as a small farming community before the Norman Conquest. In the thirteenth century, the Barlow family of Barlow Hall built a chapel in Didsbury for their own use, but it was also used by local people because the parish church was several miles away in what is now central Manchester. During the Black Death in the fourteenth century, permission was granted to open a graveyard in an attempt to prevent the plague being transmitted between Manchester and Didsbury. It was around this chapel that the original village of Didsbury grew up. However, during the nineteenth century, when Didsbury began to develop as a residential area, the centre of the village moved to the junction to Wilmslow Road, Barlow Moor Road and Hardman Street (now School Lane), close to the railway station. This photograph, taken in 1924 by a photographer with his back to Barlow Moor Road, shows the junction of Hardman Street and Wilmslow Road. It clearly reveals how narrow this portion of Hardman Street was (and still is). In the background is the bridge over the Midland Railway's line from Manchester (Central) to the Peak District and London (St Pancras). To the right of the picture was a coal yard that was first mentioned in the trade directories in 1858 when the agent was Samuel Sharples. Hardman Street was renamed School Lane in 1930 when the cottages on the left-hand side of the street were demolished and plans made to widen the road to make it part of the main road to Stockport. With the outbreak of war in 1939, the proposals were not implemented. The site of the coal yard and cottages is now a car park. The shop on the right, with its fine painted advert on the gable wall, was built early in the twentieth century, replacing a two-storey block which appears to have been shops at street level and to have had living accommodation above. The building on the left was erected in 1881, shortly after the opening of the station a few yards away, and is a sign that the railway was expected to increase the number of people in the area, creating a demand for more goods.

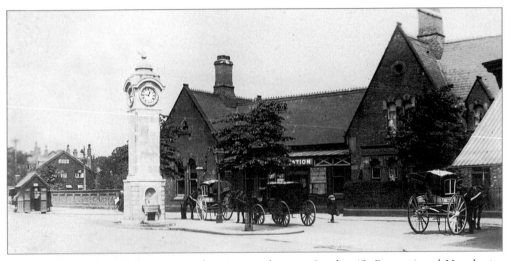

In 1880, the Midland Railway rerouted its services between London (St Pancras) and Manchester from London Road station to the newly completed Central station. Several new stations were built in south Manchester to cater for the communities through which the new line passed. One of the most important was Didsbury, which opened in 1880, and provided a fast, efficient way to get into central Manchester. The new station was opened where the railway passed under Wilmslow Road, close to the junction of Barlow Moor Road and Wilmslow Road, and near to where the new centre of the village was developing. Initially, the trains tended to cater for the businessmen and merchants who lived in the area, getting into Manchester after 9 a.m., but gradually the number of services increased so that by the beginning of the twentieth century, there were both early morning and late night trains to and from Manchester. In addition, some of the long-distance trains also stopped at Didsbury, including services travelling between London and Manchester. This photograph of the front of the station shows the monument erected in memory of Dr J. Milson Rhodes who took an active part in local politics and was involved with attempts to improve the lot of those in the workhouses, especially those who had epilepsy. He died in 1909 and the memorial was put up the following year, incorporating a clock, drinking fountain and horse trough. (*J. Ryan*)

As the population of Didsbury grew in the nineteenth century, the original parish church of St James became too small. Coupled with this, the centre of the village moved closer to the junction of School Lane and Barlow Moor Road. To meet the needs of the growing number of people living in this area, Manchester Diocese decided to create a new parish in the new centre of Didsbury. Emmanuel Church was built close to the junction of Wilmslow Road, School Lane and Barlow Moor Road. The church was consecrated in 1858 and cost £3,000. However, there was no endowment for a permanent vicar or a home for one. In addition, there was still money owing from the actual building of the church. In order to clear the debt and build a vicarage, a bazaar was held in 1859, which was attended by local people and dignitaries to help raise money. This photograph shows a performance by a band, possibly one of those from a regiment based in Manchester. It is interesting to note how many of the people must have arrived by carriage – their transport is waiting for them to leave.

Opposite, bottom: Unlike suburban railway stations today, Didsbury had its own staff, some of whom stayed for many years. This undated picture shows them in the days when the Midland Railway operated services through the area. According to a Mr Alfred Marlow, who wrote during the interwar years, there was a stationmaster, booking clerk and head porter, but there must have been others as well. Does this photograph show any of these people? In addition, the station had a bookstall which was well patronised by passengers. It would be interesting to try to identify these smartly dressed employees of the Midland Railway who served the residents of Didsbury. (*J. Ryan*)

One of the curiosities of Manchester is the way certain areas have always been referred to as 'villages', even today when they are part of the city. This stems from the time when they were separate communities whose only links with Manchester were the fact that they were within its ecclesiastical parish and within areas owned by the lords of the manor of Manchester. The best known are Didsbury and Chorlton but others, including Rusholme, Withington and Fallowfield, were also called 'villages' by local people. This postcard shows the centre of Fallowfield in the early twentieth century with no traffic at all on Wilmslow Road. Today, the road is choked with vehicles, but the buildings on the left of the picture have survived and are still shops. The ones on the right, however, have disappeared. When this photograph was taken the shops were occupied by a wide range of firms catering for the local community, including a branch of the Manchester & Liverpool District Banking Co., a greengrocer, a confectioner, a milliner, an ironmonger, the offices of the *South District Advertiser*, a newsagent, butcher and fruiterer. On the opposite side of the road (the right-hand side of the illustration), were a wine merchant, a fishmonger, a tailor and many others.

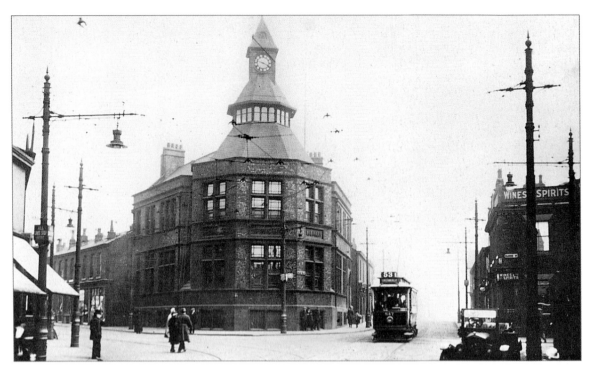

In December 1901, Gorton was presented with its first public library as a result of the generosity of local mill owner John Buckley. The family had lived in Gorton for many years and John Buckley was well known in the district as a member of the local board of health and later the Gorton Urban District Council. According to a report of the speech he gave at the opening of the library, Buckley said that he wanted to 'make a gesture in his lifetime to the people of Gorton where he has always lived and worked'. The library, which cost £3,000, was also a commemoration of the golden jubilee of Queen Victoria's reign. It was on Cambert Lane and provided Gorton with a facility for which other districts would have to wait. The books were provided not by the council, but by donations, in both cash and kind, from prominent local residents including £100 from Colonel Peacock of Beyer Peacock & Co. Across the road from the library was St James's Church, where Buckley was buried in 1916. This photograph dates from 1906.

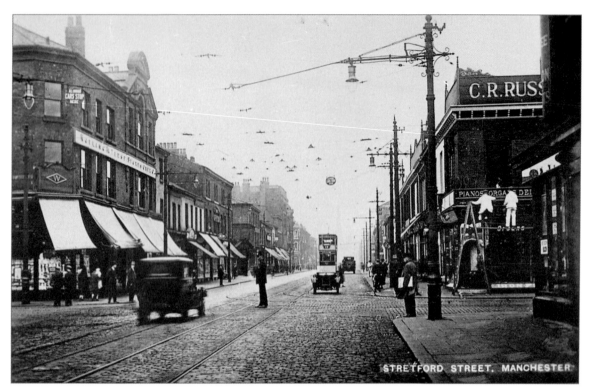

One of the main routes through Hulme was Stretford Road. (The person who put the caption on the postcard had got his details wrong because Stretford Road has never been known as Stretford Street.) It leaves Oxford Road at All Saints and eventually meets up with Chester Road in Old Trafford, providing a spine for this important residential suburb. There were not only many shops along its length, but also Hulme's Town Hall and library, focal points for the community, and the Chorlton Union Town Hall until it moved to Withington. This postcard shows Stretford Road between the wars when motor vehicles were becoming much more common. The photograph was taken at the junction of Stretford Road with Great Jackson Street and Upper Jackson Street. On the left the building occupied by Woolworth's can be seen, while on the right are the premises of C.R. Russell, piano dealers. This firm had taken over the building from another piano dealers, William Kenna Smith, in about 1927.

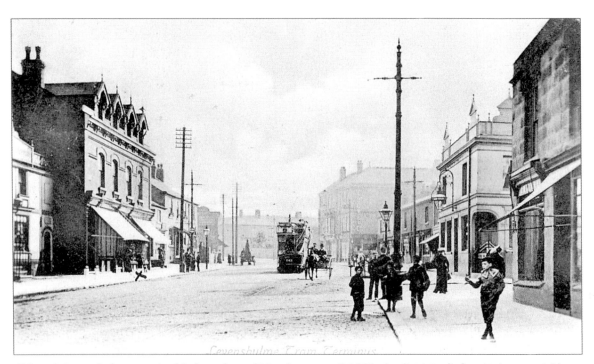

Levenshulme Tram Terminus

Although Levenshulme remained independent of Manchester until 1909, the district relied on its larger neighbour for certain services including gas, water and electricity. In 1901, when Manchester took over the running of the electrified tramways, Levenshulme granted permission for electric trams owned by the city to run into the area, subject to the drivers and guards being licensed by the Levenshulme Urban District Council and Manchester paying a fee for this licence as well. The first electric trams ran into Levenshulme in 1902 terminating near the junction of Albert Road and Stockport Road. Eventually, services were extended through to Stockport and Hazel Grove. This photograph shows the tram terminus in around 1902 or 1903 when the main road to Stockport was relatively quiet and peaceful. It was Manchester's responsibility to ensure that the roadway was maintained where the tram tracks were located. The introduction of electric trams provided the first real competition for the railways, especially when the tram service started early in the morning and ran at a frequency which the railways could not match. On the right, just behind the children, is the Railway Inn, which was probably built around the time the railway opened in 1842. On the left is Pack Horse Hotel which claimed to have been licensed in the sixteenth century and was rebuilt in 1907. This public house may have taken its name from the fact that pack horses probably stopped here on their way into or out of Manchester because the road was the main link between the city and Stockport.

When and why this photograph was taken is not known. All that can be ascertained is that it was taken by someone named 'A. Lister' and that it was posted in Levenshulme to a Miss S. Evans at 25 Kensington Road, Rusholme, on 18 June 1906. Examining the photograph, it appears that the children are all dressed in their best clothes and that there are adults present, also dressed in their best. This might have been a school or Sunday school outing in connection with Whit Week.

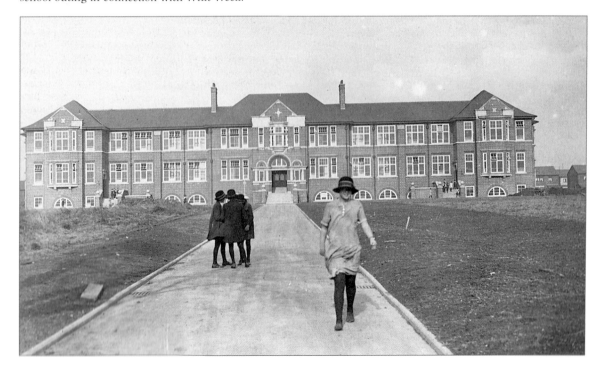

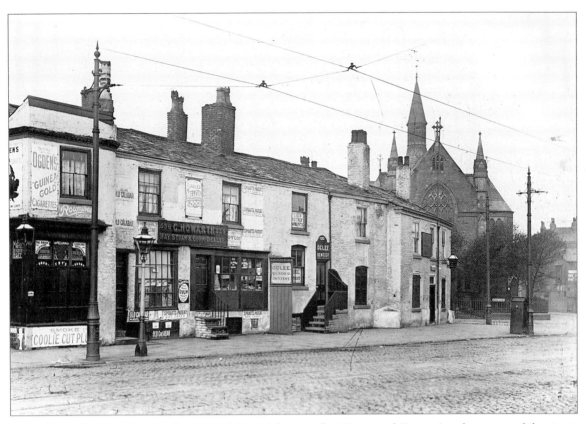

A well-known landmark on Stockport Road, Longsight, was the Wagon and Horses (on the corner of the street, with the lamp attached), which was demolished in about 1998. The site appears to have been occupied from around 1690 although the building in the picture was probably erected later in the eighteenth century. The public house probably derived its name from the fact that it was a stopping place for wagons on their way into and out of Manchester. An indication of the amount of horse-drawn traffic that passed through the area is the notice over one of the shops: 'C. Howarth – Hay and Straw and Corn Dealer'. This type of business was a vital part of the economy in the nineteenth century as everything had to be carried within towns by horse-drawn vehicles. Between Howarth's and the public house is a 'mechanical' dentist, who appears to have operated a sort of 'hire purchase' arrangement for treatment, an indication that those who lived in the area were not wealthy and could not afford to pay outright for their dental treatment.

Opposite, bottom: In 1919, Manchester Education Committee issued an important report stating that it was 'to take immediate steps for the development and provision of secondary education within the City, with the ultimate object of granting free secondary education to all children . . . who are desirous of, and who show capacity for, such education'. In order to meet the growing demand for secondary schooling and the expected increase in the number of pupils as a result of this new policy, the committee decided that three new schools would be required and that they should be built as soon as possible. The last of the three to be completed was Levenshulme High School for Girls, whose first pupils arrived on 3 September 1929. The new school was set in 12½ acres of grounds, which meant that it had its own playing fields, and had places for 540 girls. The buildings cost £77,000 and included seventeen classrooms, a lecture room, laboratories, library, hall and domestic science rooms. This photograph, taken in 1931, shows not only the buildings, but also the school uniform which included a hat. When the school was built, this part of Levenshulme was gradually being developed as both private and council houses were erected here.

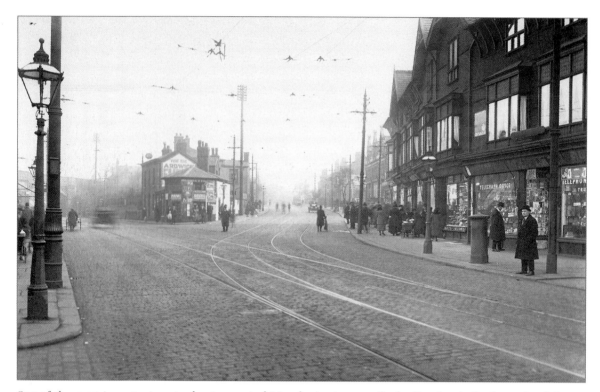

One of the most important routes leaving central Manchester in a southerly direction is Stockport Road, better known today as the A6. It roughly follows the line of a Roman road between Manchester, Stockport and Buxton, and became a turnpike route as a result of an Act of Parliament passed in 1724. After the Act it was widened and improved, and the original legislation was renewed on many occasions until 1885 when it lapsed. At regular intervals along the turnpike were toll-houses where travellers paid a fee for the privilege of using the well-maintained road. One was situated at the junction of Slade Lane (on the right) and Stockport Road (on the left). It was reported in 1803 that this toll-bar took over £1,000 a year from passing traffic. This amount probably did not include the fees paid by stagecoaches, whose owners often compounded the tolls and made an annual payment. The toll-house seen in the centre of the photograph was demolished in 1934 when improvements were proposed at this major road junction. This photograph was taken in March 1924 and shows the building in the centre of the junction with its advertisements for Bovril and Lyons tea. The shops on the right are still there and many now sell foodstuffs associated with the Indian subcontinent and the West Indies. The post office has also survived.

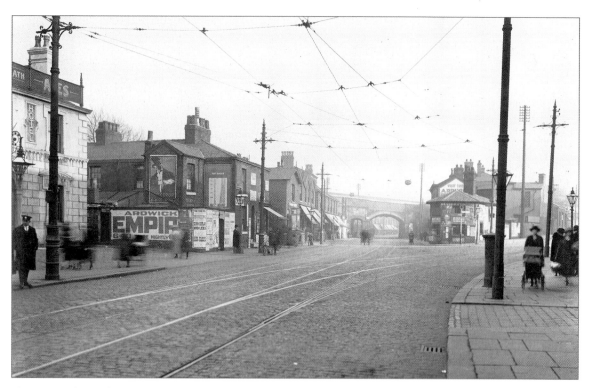

This image shows the other part of the Slade Lane/Stockport Road junction – the photographer is looking along Stockport Road. Like the previous picture, it was taken on 13 March 1924 at a quiet time of day. Behind the toll-house, on the right-hand side of the photograph, is the bridge which carries the main Manchester to Stockport railway line, opened in 1842 and widened in the late nineteenth century as the amount of traffic increased. The bridge was rebuilt in the late 1950s as part of a programme of modernisation and electrification of the line to London. For a short time, there was a station known as Rushford near the bridge, but it was closed when Longsight station was opened. The row of shops and the short street on the left between the public house and the railway bridge have been demolished and the site landscaped. The shops which can be seen on the far side of the railway bridge still remain, although some are in poor condition. Taken together, this and the preceding photograph provide a fascinating glimpse of a major road junction in the days when cars and motor lorries were few and far between and when trams were the main means of public transport.

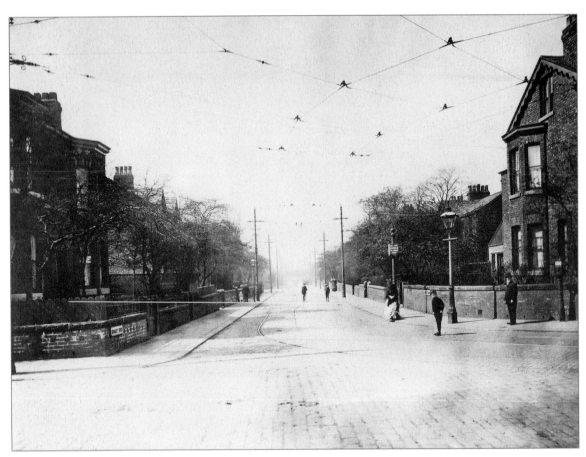

In the late nineteenth and early twentieth centuries, Longsight was a desirable residential suburb for the increasing number of people employed in the shops, offices and warehouses of Manchester. Efficient horse trams, and later electric tram services, coupled with workmen's fares, made it possible for working people to move away from the overcrowded areas near to the centre of Manchester and live where houses had small front and back gardens together with facilities like running water and gas. This photograph, taken in 1914, shows Stanley Grove, Longsight, at its junction with North Road. This was the residential part of the Longsight, away from the hustle and bustle of the main Stockport Road. The houses all have front gardens and several appear to have rooms in the attic as well. According to the 1914 directory, the residents of this part of Stanley Grove included a potato merchant, several householders, a portrait painter, a clerk, a physician and a surgeon, a clerk, a plumber, an insurance agent and a grocer. In the background is a bridge carrying the railway line between Manchester and Stockport. The tram route was the well-known no. 53, which carried vehicles that were specially constructed to allow them to pass under the railway bridge.

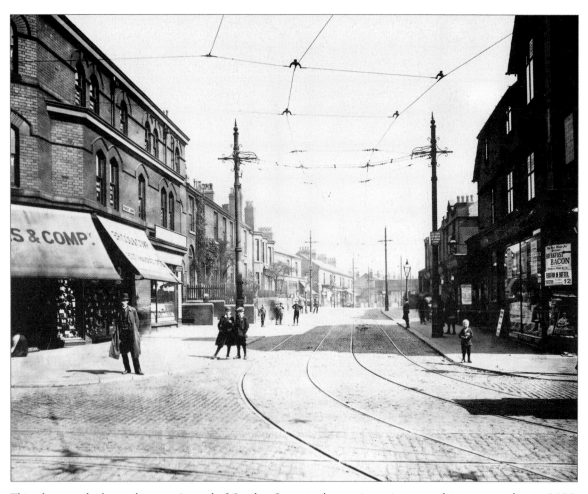

This photograph shows the opposite end of Stanley Grove to the previous picture, and it too was taken in 1914. This was the junction with Stockport Road. The character of this end of Stanley Grove was quite different. Although there were a few houses here, most of the property was of a commercial nature. On the left-hand corner is Briggs & Co., which made and repaired shoes. Beyond the shop are several houses occupied by a clerk, a decorator and people described in the directory for this year as 'householders'. Further along is a short row of shops which included a baker, a hairdresser, furniture broker and a shopkeeper with no specified type of business. On the right is a branch of Seymour Meads, a well-known and well-respected grocer in the Manchester area, the address of which was given as Stockport Road. The first building actually to have a Stanley Grove address was the local Conservative Club beyond which was a boot and shoemaker, a laundry, a confectioner and a watchmaker. All the properties in this photograph have now gone. The left-hand site is part of a shopping centre which includes a supermarket, while the site occupied by buildings on the right is still vacant and in June 2000 was being marketed for development.

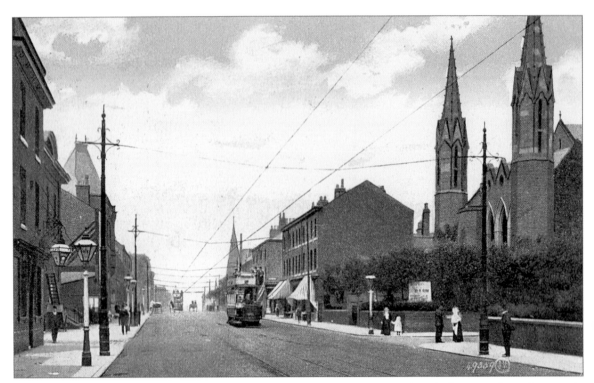

This postcard view of Stockport Road, Longsight, from about 1904 was taken looking northwards towards Manchester from the junction with Plymouth Grove. The church on the right was Longsight Independent Chapel, designed by Travis and Mangnall and built at a cost of £5,000, including fittings and fixtures. It opened in 1853 and was often known as 'Ivy Chapel' because the front wall gradually became covered with the plant. During the nineteenth century, the chapel was a fashionable place of worship, but as the character of the area altered, its congregation declined and it closed in 1933. For a short time it was occupied by a fun fair, but after the Second World War the building was demolished. Across the road, on the extreme left of the picture, is the Farmer's Arms pub and next to that is Longsight Public Hall and what a directory refers to as 'Fire Escape Station'. It was in the public hall that Longsight Mechanics Institute was founded in 1850s, a library developed from the institute. The building housed the Longsight branch of Manchester Public Libraries until 1978 when the present one was opened a few yards away on the opposite side of the road.

Opposite, bottom: Miles Platting is an area that people tend to pass through unless they either work or live there. This photograph was taken five days after the one at the top of page 85, by which time the weather had changed. It shows the junction of Oldham Road with Hulme Hall Road. The lack of people around and the fact that the shops appear to be closed and have their blinds down suggests that 23 March 1924 was a Sunday. The importance of such a photograph is that it shows the type of shops that were to be found in many of Manchester's suburbs, even the working-class ones. On one side of the road is the store run by John Bloom, draper, who also occupied 124 Oldham Road, two doors down from the shop on the right of the photograph, where he described himself as a 'costumier'. Next door to the Bloom's store on the left was a small shop belonging to Joseph Pearse, draper. The residents of houses on the left-hand side of the road included a bricklayer, a piano dealer, a milliner, a farrier and a spinner.

Miles Platting has been described as one of Manchester's inner city suburbs although it lies over a mile from the city centre at the junction of the railway lines from Manchester Victoria to Yorkshire via Stalybridge or Rochdale. The area was divided by several main roads, including Oldham Road and Hulme Hall Road. This photograph, taken in mid-March 1924 looking towards Oldham Road, shows some of the houses that lined Hulme Hall Road. The houses all have small front gardens and would have had small rear yards or gardens. The houses on the left appear to be older than those on the right. Their front gardens are surrounded by wooden fences while those on the right, with their bay windows, have small walls topped with railings. However, these front gardens were not very large: when the window cleaner called, he had to put his ladder on the pavement to be able to set it at a safe angle. In the background it is just possible to make out the railway bridge on the other side of Oldham Road where Miles Platting station was located. In 1924, the people who lived in the houses on the right of the photograph included a platelayer (no. 58), a plumber (no. 56), a warehouseman (no. 46), a mechanic (no. 42) and a tailor's presser at no. 40. On the left, the residents included a nurse (no. 61), a draughtsman (no. 59), a foreman blacksmith (no. 55), a solicitor (no. 47) and a cycle dealer at no. 43. Further along the road, behind where the photographer stood, was the Albion Iron foundry, occupied by West's Gas Improvement Co., manufacturers of gas meters.

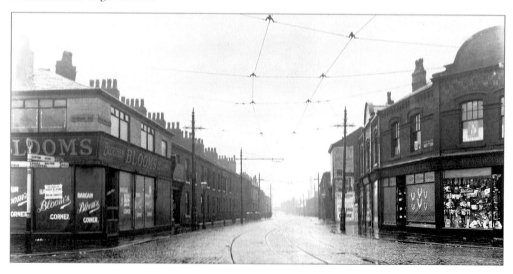

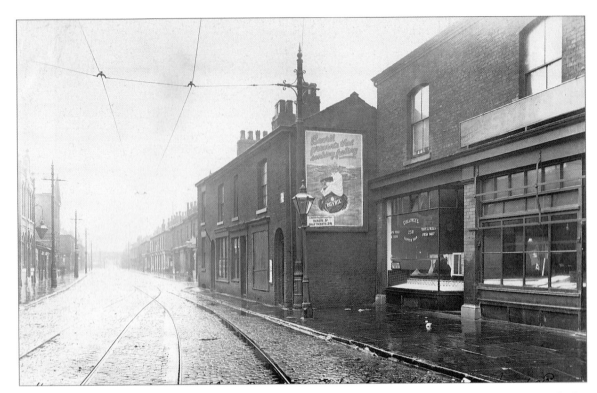

The photographer who took this image of Queen's Road, Miles Platting, on 23 of March 1924 must have had a busy morning for he also took several other shots of this area at the same time. Some of the properties appear to be older than those on Hulme Hall Lane as they have no front gardens and many come quite close to the edge of the pavement. The fact that the adjacent properties are set back provides an ideal location for a Bovril poster, which appears to be offering a special deal on the railways. The shops on the right-hand side of the photograph are just a few of the many on this section of Queen's Road. Among them were a pork butcher's, the British & Argentine Meat Co. (1923) Ltd, Meadow Dairy Co., and a grocer's. The butcher's shop next to Collinge's fish and chip shop was owned by a Mrs Smith. The shop with its shutters up was a clogger's, next door to which was a cycle repair shop. The block was completed by a hairdresser and a fishmonger. Hidden from view is the town sub-post office and money order and telegraph office. Other traders in the block include a tripe shop, another clogger's shop, Mrs Walton's dining rooms, a wallpaper distributor, another café, a tobacconist and a confectioner's – certainly all the shops local people required. On the left is the local United Methodist Church and its associated buildings.

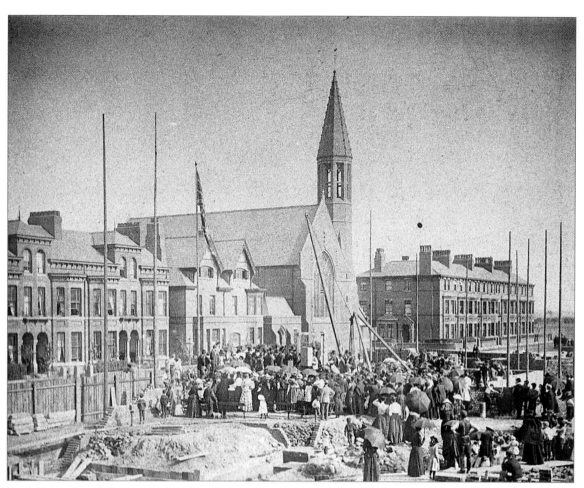

Until 1904, Moss Side was separate from Manchester and it tried to retain its independence longer. It asserted this in education. In 1870, the Forster Education Act introduced the concept of compulsory education, although at this time it was not free. School boards were to be elected and charged with the responsibility of ensuring the implementation of the act. Those elected to school boards stood for various reasons. Some became involved because they had an interest in education while others did so in an attempt to ensure that a particular viewpoint was represented. One of the major problems facing many boards was the lack of adequate school buildings. Although some church schools were handed over to the boards, many remained in the hands of the churches, who preferred to ensure that children were given a Christian-based education rather than a secular one. In Moss Side, the school board tended to include a number of representatives of the various religious denominations who were always jockeying for position. Despite the disagreements, new schools were built in the area to meet a growing demand. In 1895, plans were drawn up and work began on the construction of a new board school on Princess Road in Moss Side. This photograph shows the large crowd which assembled to witness the laying of the foundation stone on what was originally a green field site.

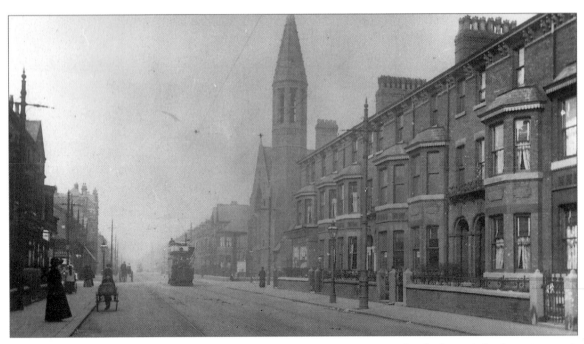

The main route from central Manchester through Moss Side is Princess Road, which until the late nineteenth century terminated at Clarendon Street at the entrance to Alexandra Park. In 1893, there were still a number of vacant sites awaiting development on Princess Road including the one opposite St James's Church, the tower of which can be seen in the centre of the picture. St James's was built between 1887 and 1888 to the designs of John Lowe. Within a short time, the empty land was built on. Some plots were used for housing while others were used for shops and Princess Road School, which is the tall building in the background on the left-hand side of the road. The houses shown in this picture can also be seen on the photograph of the laying of the foundation stone of Princess Road Board School on page 87.

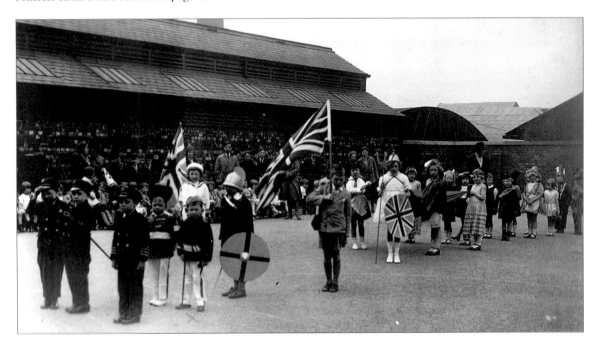

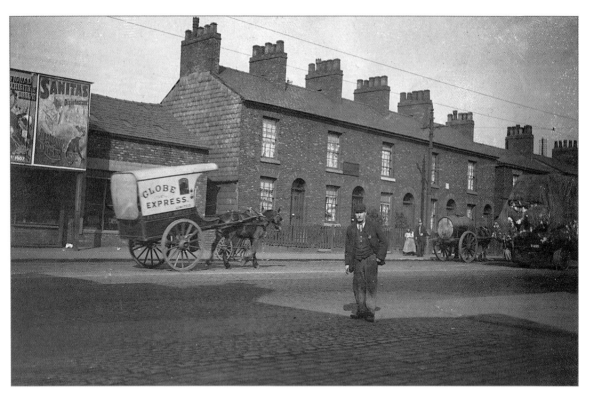

This photograph of Oldham Road, Newton Heath, was taken in 1909 although the exact location is not recorded. It is possible that it shows an area close to St Wilfrid's Church. The photograph depicts the type of cottages originally built along this important arterial road. The delivery van belonging to Globe Express was the forerunner of the modern parcels delivery service. Other vehicles shown in the photograph include a water cart and a lorry piled high with what appears to be cotton on its way to a local mill from the docks or the railway in Failsworth or Newton Heath.

Opposite, bottom: Moston is one of Manchester's north-eastern suburbs and derives its name from the fact that it was originally a small farmstead on the edge of mossy land. The *Victoria County History* commented that it 'had a hilly surface' and that it 'had various works including a wire manufactory and a colliery'. It was not the type of area that appealed to the editors of the series because it had no large stately houses or old churches. However, the area does have its own history of which the local people are very proud. This photograph, like so many that were taken of groups, contains no information about the date, what the event was or where it was held. One can only surmise from the dress and the costumes which the children are wearing that it might be between the wars and that it marked Empire Day, which was held in the spring each year.

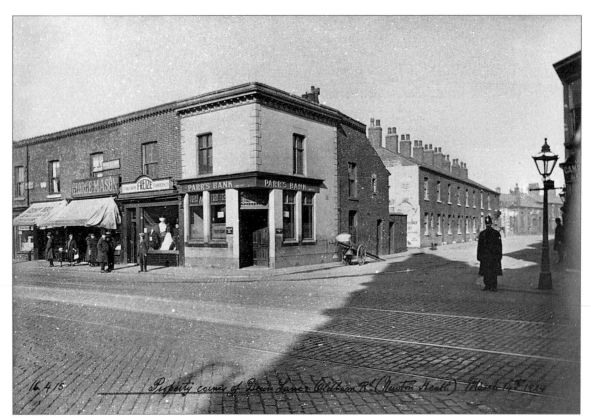

Newton Heath was included in the parliamentary borough of Manchester in 1832, but when it was proposed that it should also be completely incorporated within the borough in 1838, there were many objections and the decision was taken to exclude it. It was not until 1890 that Newton Heath became part of the city, by which time the population had reached over 36,000. In the nineteenth century a report by an inspector from the General Board of Health concluded that the sanitary condition of the township was very bad and that there was widespread opposition to the introduction of any aspect of the recently passed Public Health Act, which allowed local boards of health to be established. He went on to argue that effective drainage of the land was essential and that there should be proper house drainage together with well-laid sewers. Eventually, Newton Heath did have its own local board of health and conditions in the township started to improve, but it was a long process. This photograph shows the junction of Oldham Road with Dean Lane in 1924. The cottages on Dean Lane were built in the nineteenth century and in 1924 were occupied by several people who described themselves as householders. Some listed their occupations, which included a tram driver, a fireman, a boot repairer, a coal lifter and a greengrocer. Further along the road were Dean Lane station and Newton Heath Locomotive Depot, which provided engines for many of the services operating from Victoria and Exchange stations. The bank in the photograph claims to be Parr's Bank, but by the time the picture was taken, Parr's Bank was part of the Westminster Bank. Next door was Freize Ltd, who were costumiers. George Mason's was a well-known grocer's with several shops in the Manchester area. The other two shops which can be seen were those of Gent Brothers, who were watchmakers, and Joseph Hall, a herbalist, on the far left. Other shops in the area included a butcher's, a greengrocer's and a milliner's.

In 1861, communications between Northendon and Manchester were improved by the construction of what the *Stockport Advertiser* of 13 December 1861 called a 'footbridge' to link Northendon with Palatine Road. The new bridge was about 10ft wide and was described as being a 'light and elegant lattice girder bridge'. It replaced a 'cumbersome' and apparently 'dangerous' ferry across the river at this point. The new bridge could probably take a horse bus, but by 1874 there were demands for a wider structure, which could take traffic in both directions at the same time and provide a footpath for pedestrians. The replacement bridge was built by the Manchester and Wilmslow Turnpike and taken over by the East Bucklow Highway Board in 1881. The widening of the bridge and the abolition of the toll bar at Barlow Moor in Didsbury encouraged people not only to travel to Northendon and enjoy the countryside, but also to consider moving out to the area from Manchester. Gradually, large houses were built and businessmen began to make their homes in Northendon. This photograph shows the River Mersey with the Palatine Road bridge across it. If the visitor was to follow the river behind the photograph, he would reach the Tatton Arms, which was a popular place of refreshment. The number of visitors was such that as well as the pub, there was at least one café on the Northendon side of the river. Whether the building in the picture was the Northendon Café owned by a Monsieur Logios is not clear. If it was, then the photograph was taken prior to November 1904 when the café was burnt down for the second time in five years. In the 1920s, the site appears to have been occupied by the Riverside Café. It had a stadium attached which was used for wrestling, boxing, skating and local events such as fund-raising bazaars. The complex closed in 1962 after fire damage. From this photograph, it is possible to see why so many people travelled out from Manchester during weekends to enjoy the scenery and even boat on the river.

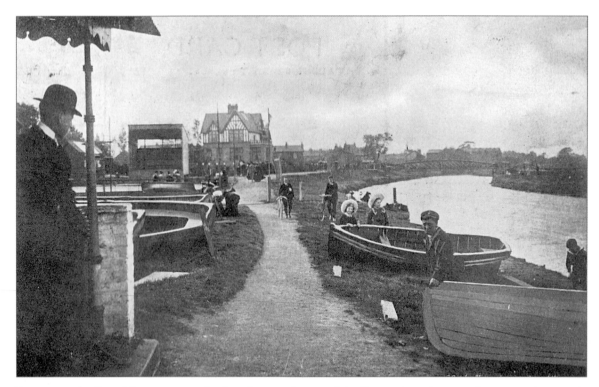

Boating on the River Mersey was confined to the stretch west of the Tatton Arms because there was a large weir there which had been constructed to allow a water mill to be built. The Tatton Arms, which can be seen in the background, was built in 1875 and replaced the Boat House Inn from which the ferry across the river to Didsbury operated. In the early twentieth century, boats were very popular at weekends with those who travelled out to Northendon from Manchester to enjoy the countryside. This photograph also shows what appears to be a small steamer which took people on trips towards Didsbury and Cheadle in the early twentieth century.

Opposite: When the first bridge across the River Mersey was opened in 1861, it enabled some horse-drawn traffic to travel between Northendon village and Didsbury and so into Manchester. In order to provide a link between the bridge and other roads in the district, a new thoroughfare was constructed, which adopted the name of the street on the Lancashire side of the river, Palatine Road. The result was that the old route along Church Lane to the ferry across the river became less busy. Gradually, shops began to appear on Palatine Road, especially around its junction with Church Lane. The top photograph was taken in about 1913 and shows that only one side of the road was built up. Although the shop in the foreground appears to proclaim its owner was Henry Handforth and that he was a provision dealer, by the time this photograph was taken, Henry appears either to have retired or died as the person recorded in the directory for this year as being at the building is Mark Handforth, provision dealer. In the early twentieth century, the stores on this stretch of Palatine Road included a hardware shop, a shoe shop, a confectioner's, a greengrocer, a milliner, an ironmonger, a draper and two other provision dealers. The choice of shops was to increase dramatically when Northendon was taken over by Manchester after the Wythenshawe estate was purchased and incorporated into the city in 1931. The area was to become a 'new town' with the result that more shops and facilities were built, including a cinema. The bottom photograph shows the shops that lined Palatine Road in the 1950s. Those on the right are where the hedge can be seen in the photograph above.

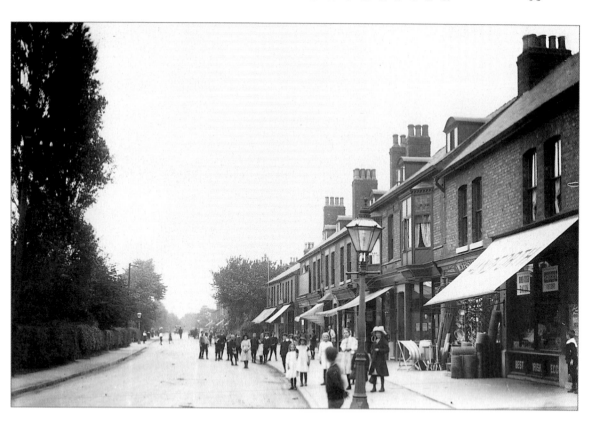

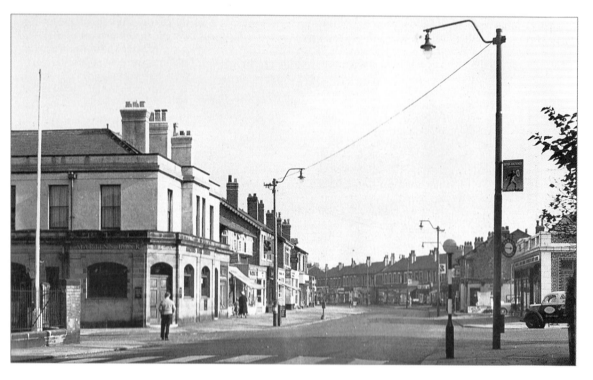

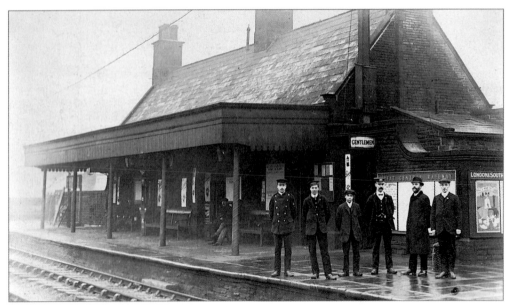

When the Manchester, Sheffield & Lincolnshire Railway built its line to Sheffield via the Woodhead tunnel, it passed through parts of east Manchester, including Gorton and Openshaw. It was here that the railway line and the natural ground level met and when Richard Peacock sought a site for his company works, he chose Gorton. In addition to the topography, another factor influenced him: the fact that the area was outside the boundaries of the borough of Manchester and therefore the rates were lower. At the same time, the area was close enough to Manchester to attract the skilled workers he required. Other companies were probably influenced by the same considerations when they came to establish their factories. Ashbury's Railway Carriage & Wagon Works was built on the edge of Gorton. Here, a substantial factory was constructed which was capable of turning out large numbers of both passenger carriages and goods wagons. It is said that the railway station at Ashbury's, shown in this photograph of about 1910, was built for the employees of the company to enable them to get to work because it was next to the factory. Ashbury's station was opened in 1855 and is still in operation today although the original buildings were demolished in the 1990s. (J. Ryan)

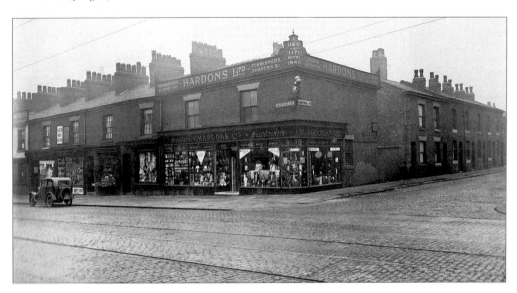

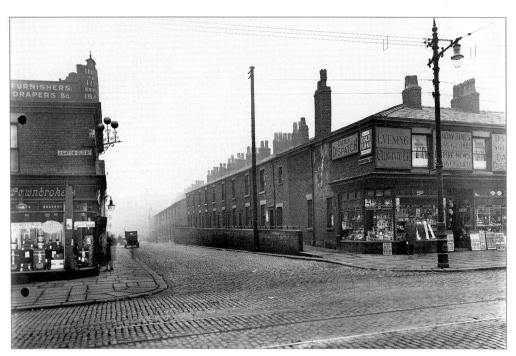

In order to get an impression of what an area looks like, it is often necessary to take several photographs that overlap each other slightly. This is exactly what the photographer who took this image and the one on the preceding page did. This shot shows the other side of Sandywell Street where there is a wall which appears to go uphill. The reason for this is unclear unless there is a slight rise in the land and as a result houses were built in such a way that there was a sharp drop from the pavement on to the road so the wall was erected to prevent accidents. The people who lived here would probably have been employed locally in the engineering works, mills or by the railway company. At the end of Sandywell Street, emerging out of the gloom is a tall building. This is Wheeler Street School, which was opened in 1902 and closed in 1967, becoming Wheeler Street Community Centre. How long the photographer waited to get the road clear of traffic will never be known as Ashton Old Road was always busy with trams passing and vehicles going to the various factories in the area.

Opposite, bottom: According to the *Victoria County History* for Lancashire, Openshaw stretches for 'over 2 miles along the Ashton Old Road, a long straight road leading east from Manchester to Ashton . . . the district is now urban, though a little open land remains on the northern border.' Between 1866 and 1890, Openshaw was a board of health like many other of Manchester's townships, but in 1889, the board decided that it would be in the best interests of the area if it merged with Manchester, a move which took place in 1890. For much of its length through Openshaw, Ashton Old Road was lined with shops and terraced houses. Behind the houses on the south side of the road were several large industrial concerns such as the Carriage & Wagon Works on the Great Central Railway (known locally as Gorton Tank and not to be confused with the Beyer Peacock works which was known as Gorton Foundry and lay south of the railway line), Armstrong Whitworth's works and the Otto Gas Engine works. The shops served the local community, providing it with everything it required. This photograph, taken in 1924, shows not only the pawnbroker's, which had been in existence since 1840, but also a greengrocer's, a newsagent's, a dress shop and a printers. From the posters on the building, it appears that Hardons were not only pawnbrokers, but also house furnishers and drapers. The houses on Sandywell Street are typical of those found in the area, built without front gardens and with the front door opening directly on to the street.

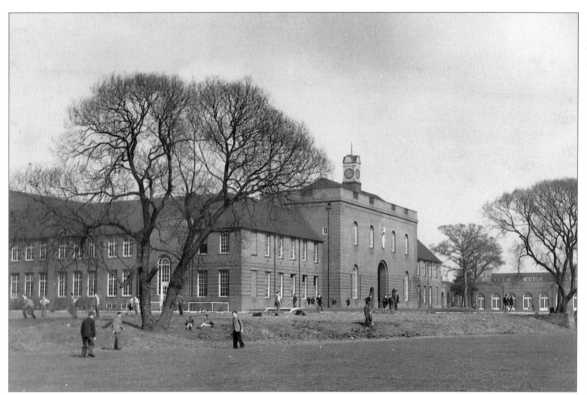

Manchester Grammar School was founded in 1515 by Hugh Oldham, Bishop of Exeter, to educate boys from Manchester and the surrounding area so that they might go to university and enter one of the acknowledged professions of the day – the church or the law. The school began in premises on Long Millgate on a site which was to become very confined because it was hemmed in by Chetham's School at its rear. As the school expanded during the mid-nineteenth century, it became apparent that the site was not ideal because there were no playing fields, no playground and the buildings had to be designed to fit the site. The number of pupils was seriously limited by space. Suggestions were made in the later nineteenth century that the school should move, but it was not until 1926 that the decision was finally taken. The school purchased the site of Birch Hall and its associated farmland in Rusholme and the new buildings were completed and opened in 1931. The new school, seen here in about 1933, was a vast improvement on the long draughty corridors, flights of stone stairs and lack of playground which the boys had previously endured. Proper science labs as well as a gymnasium and swimming pool were incorporated into the new site. Once the school had moved, the old buildings, which were said to cover 3,989 square yards, were sold and used first as a college to train mature people for teaching and more recently as part of Chetham's School of Music.

The prospect of Platt Hall and its associated estate being sold off to developers in 1905 and 1906 roused the residents of Rusholme who, under the leadership of William Royle, fought a campaign to save it for Manchester and convert it into a public open space. This photograph appears to have been taken when the estate was first put on the market in 1905, but as it did not reach the reserve price, the sale was withdrawn. The notice was very carefully sited on the corner of Platt Lane and Wilmslow Road. Platt Hall was the home for several centuries of the Worsley family. Lieutenant-General Charles Worsley was involved in the removal of the mace from Parliament in about 1651 and also represented Manchester in Parliament in 1653.

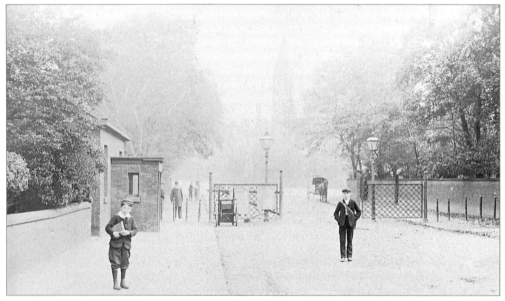

Victoria Park was created in 1837 as a residential area for the businessmen of Manchester who wanted to escape the increasingly unpleasant conditions in the centre of the town and yet be within easy reach of their firms. The development of the horse bus gave an impetus to this outward expansion. In 1837, a company was created to develop a residential estate on the edge of Rusholme and Chorlton-on-Medlock, sandwiched between Wilmslow Road and Plymouth Grove. The area was walled off and the erection of large houses began, the estate being laid out by Richard Lane. However, the development company collapsed in 1842 and it was another three years before the Victoria Park Trust was created to complete the plans. In order to keep the estate as select as possible, the entrances were protected by gates and porters were engaged to keep out unwanted visitors. This gate, photographed in about 1900, was located on Anson Road, where those who wished to use the road to leave Manchester were charged a toll. Even in the 1920s, trams were subject to restrictions when they passed along Anson Road. It is said that children used to play a game of trying to creep into the park under cover of a tram. The toll-gates were eventually abolished in 1937 and access to the park became open to all.

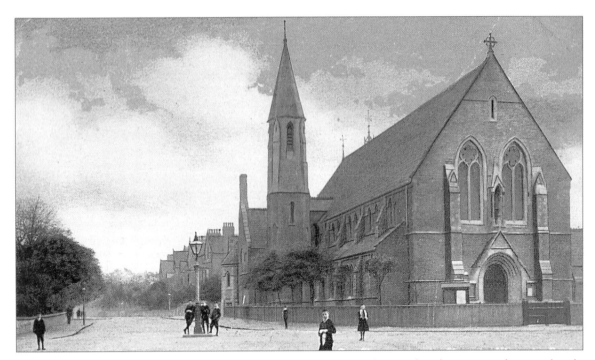

In 1874, a new church was built on the edge of Victoria Park, dedicated to St John Chrysostom. The new church, which cost £13,000, was dedicated in 1877 and served not only the residents of Victoria Park, but also neighbouring parts of Chorlton-on-Medlock. In 1904, the church was destroyed by fire, the damage being so great that only the tower and the four walls were left standing. In 1906, the church was re-opened, having been rebuilt with the help of John Ely, a local architect, who tried to reproduce faithfully G.T. Redmayne's original designs. This postcard shows the church standing in its dominant position on Anson Road, but there is no date on the card and so it is impossible to say whether the picture was taken before or after the fire.

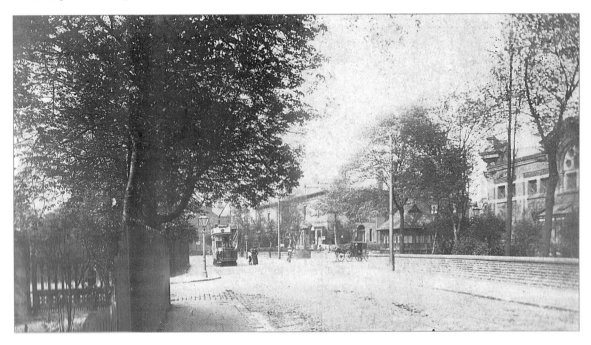

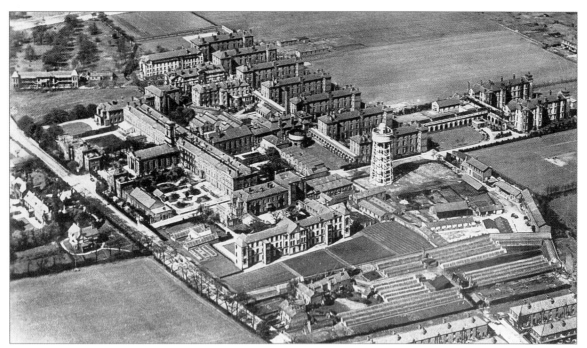

During the nineteenth century, Manchester was divided between three poor law unions, the largest of which was Chorlton, stretching from the River Medlock to the River Mersey. The union included densely populated suburbs such as Hulme and Chorlton-on-Medlock, as well as the residential villages of Didsbury and Withington. The original workhouse was on Stretford Road in Hulme, but by the mid-1850s it had become apparent that the existing buildings were inadequate to cater for the rising number of applicants for shelter. A decision was taken to move to a green field site in Withington where there was room for expansion and land for the workhouse to grow some of its own food. The original buildings, including the chapel, are on the left-hand side of the photograph. The seven parallel buildings behind were added later as hospital blocks designed by Thomas Worthington with advice from Florence Nightingale. When the workhouse opened on its new site, there were around 750 inmates, but by the end of the century the total had risen to over 1,100, many of whom were elderly and infirm, suffering from problems such as epilepsy, or were 'lunatics', orphans or abandoned children. When the poor law system was finally abolished in about 1928, the former Withington workhouse was handed over to Manchester City Council, which improved it and converted it into a general hospital. The hospital, seen here in about 1945, was taken over by the National Health Service in 1948/9. Recently its future has been in doubt.

Opposite, bottom: Whalley Range came into existence after Samuel Brooks, a Manchester banker, acquired land on the edge of Moss Side and Stretford in 1836. When he purchased the site, it was said that the only way across it was a footpath and that there was a need for the area to be properly drained before it could be developed, which cost him £12,000. Brooks named the area after the place of his birth, Whalley in Lancashire. Many of those who moved there were professional people who wanted to have easy access to Manchester, yet live in pleasant surroundings. This picture shows Withington Road which started at Brooks Bar and terminated at Wilbraham Road, although in the early twentieth century there was no development beyond Manley Road. Although many of the houses were numbered, they also had names such as West Bank, Thorncliffe, Hughendon Villa and Alton Towers. At the junction of College Road and Withington Road stood Withington High School for Girls, while further along College Road was the Lancashire Independent College where ministers for the Congregational Church were trained.

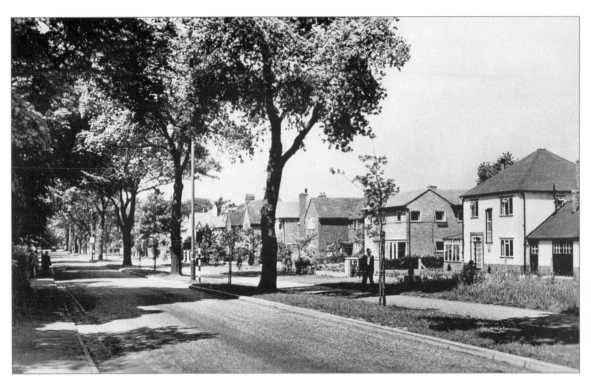

When Manchester embarked on a programme of slum clearance in the 1920s and 1930s, the main problem that faced the city council was the demand for land on which to build council houses to replace the homes that were to be demolished. In 1926, Manchester was given Wythenshawe Hall and Park by the Simon family and then purchased a considerable amount of extra land on which it planned to create a 'new town' with all its own facilities. Work started on putting in the infrastructure and building the houses before the outbreak of war in 1939, but during hostilities the project was suspended and some of the facilities were not completed until the 1970s. Among the earliest areas to be built up were those which bordered existing streets like Wythenshawe Road, shown here in the early 1950s. Although there were some maisonettes constructed, many of the new properties were houses with their own front and back gardens – facilities the new occupants would not have had in the inner city. Where possible trees were planted along side roads and grass verges were introduced. It must also be pointed out that not all the development which took place in Wythenshawe was carried out by the council. Some was undertaken by private companies to meet the growing demand for houses in the suburbs. The properties in this photograph were privately owned and at least one has a garage, something which the council houses did not have because only a few people owned cars.

CHAPTER FOUR

WHEN AT WORK . . .

From the end of the eighteenth century and throughout the nineteenth century, there was tremendous growth in industrial production in and around Manchester brought about by the use of steam power to drive machinery. Previously men and women had worked at home or in small, water-powered mills and factories, often in remote areas where there were fast flowing streams. Now men, women and children worked in larger numbers in mills and factories in the towns. Not only were the mills and factories getting bigger, machinery was also going faster, enabling production to be increased and new ideas pushed industrialisation forward. Manchester was regarded not only as the 'capital of the weavers and spinners', but also as a place to see steam power fully exploited.

Large towns have always attracted men and women in search of work and wealth. This had certainly been the trend throughout the eighteenth century, but with the end of the Napoleonic Wars, large numbers of men discharged from the services made their way to the growing industrial centres in the hope of making a fortune. Some were successful, but many were not. During the years after 1815, there was a good deal of unrest as factory owners struggled to adjust their production to the peacetime economy. Unemployment rose and there were demands for both economic and political reform. One of the largest meetings ever held outside London took place on 16 August 1819 at St Peter's Fields in Manchester. The dispersal of the meeting by the military on the orders of a frightened magistracy resulted in eleven people being killed or dying from their injuries; several hundred were seriously injured. The event became known as the Peterloo Massacre.

Although Peterloo ushered in a period of repression, it was not long before some of the legislation was amended. For instance, in 1824, the Combination Acts were repealed and trade unions were able to form. This prompted a rash of strikes, often led by spinners whose lack of activity could paralyse the textile industry. As a result of the strikes Richard Roberts, a Manchester engineer, was asked to develop a self-acting mule. This machine was designed to enable many of the operations carried out by mule spinners to be done automatically. This allowed the spinning of cotton yarn to be undertaken by semi-skilled hands rather than specialist workers who could bring the industry to a halt if they became involved in an industrial dispute. It took six or seven years before the self-acting mule was perfected. Roberts was one of a number of inventors who lived and worked in Manchester during the nineteenth century and helped to make it such an important industrial centre.

Although Manchester had a large number of different types of industry, producing goods for sale was not the only way people earned a living. During the nineteenth century, the centre of the city gradually became dominated by warehouses, offices and shops. The warehouses connected with the textile trade employed large numbers of people and

Manchester is regarded as an industrial city, but when it absorbed Wythenshawe in 1931, it acquired a large rural area in north Cheshire. The City Council intended to develop the area for housing so that residents from the slums could be relocated in what Lloyd George had described in 1919 as 'homes fit for heroes'. It was some time before the first houses were built and not until after the Second World War that development began in earnest. This photograph shows a farmer ploughing land in Wythenshawe between the wars. The scene looks very rural, but within thirty years, farms like this had almost disappeared under a sea of new housing. Wythenshawe's farmland was not the only property to be taken over for development. Many of the small farms which existed in Manchester, especially in the southern part of the city, gradually disappeared as more council houses were erected.

generated much business. The first modern textile warehouse on Mosley Street by Edward Walters for Richard Cobden. Many of the new warehouses had impressive entrances with the ground floor reached via a flight of steps, while inside there were large open spaces. Here the products of the various mills could be viewed by potential customers without having to travel to the mill. This was a development of the system whereby mill owners brought their goods to Manchester and lodged them at inns on certain days of the week. It also ensured that unwelcome visitors, especially from abroad, did not visit the mills and see machinery which they might try to copy when they returned home. The warehouses not only brought employment for warehousemen and mill operatives, but also business for the post office, railways and carriers. There was also the Royal Exchange, the focal point of the textile industry and all those industries whose commercial success relied to some extend on the cotton trade. It too was based in central Manchester.

Much of the production of the Lancashire textile industry and Manchester's engineering industry was for export. Those involved in the trade complained of the rising value of the pound, of American industry dumping goods on markets and the problems of high transport costs. The skill of the exporter was to gauge when the market was flooded in order to avoid having large stocks abroad or at sea which had to be sold at a loss as prices fell, and to judge when stocks were sufficiently low abroad to start exporting again. At the same time, falling export demand often led to rising unemployment at home and depressed prices, so good bargains could be had, and if the timing was right, the exporter would get his goods into the overseas market when stocks

had run out and prices were rising. Some were very successful. For instance, John Owens, a merchant whose father started as an umbrella manufacturer, left over £168,000 when he died. Of this, over £98,000 was given to establish Owens' College, now Manchester University, in 1851. He was involved in the export of woollens to South America in the 1820s and 1830s.

During the mid-nineteenth century, Manchester was one of the leading centres of economic theory in England. The Manchester School of Economic of Thought promoted free trade of goods. By adopting this policy the academics believed other countries would be encouraged to remove their barriers and so help trade develop which would benefit the manufacturers back home. The movement developed out of the Anti-Corn Law League, whose aim was to achieve the repeal of the Corn Laws. This legislation had been introduced to protect farmers from foreign competition and only allowed grain to be imported when prices reached a certain level. It was finally repealed in 1846.

As well as large manufacturing industries, there were many small businesses in Manchester. Some grew into industrial giants while others continued to serve local or home markets. In Manchester there were one-man firms as well as companies employing over 1,000 people, small factory and workshop owners who managed just to survive as well as multi-millionaire industrialists, merchants and financiers.

The selection of photographs in this chapter shows aspects of both manufacturing and commercial life in Manchester during the last 150 years.

In 1931, Wythenshawe was absorbed by the city and became the location for a 'new town'. At that time, Wythenshawe was still largely rural with scattered farms and country lanes. This photograph, taken a few months before the outbreak of the Second World War, shows Greenbrow Lane at Baguley as the grass verges are cut by a workman using a scythe. The farmhouses and barns in the background and the trees spreading across the road give the impression of a corner of rural England, yet only a few miles away, council estates were being constructed and the quiet of a summer's day was occasionally punctured by the noise of aircraft using the newly opened Ringway Airport.

Until the internal-combustion engine became widely used, horses provided the power to haul wagons carrying goods to and from factories, mills, railway sidings and quayside and to haul buses and trams. The large number of horses meant that there was always plenty of work for blacksmiths and farriers. According to the 1836 Manchester trade directory, there were forty-six blacksmiths in central Manchester and this number had risen to over 162 by the 1870s. However, by 1900, the figures had begun to decline with only about 140 listed in the directory for that year. In addition, blacksmiths made an important contribution to the local economy in the surrounding districts like Rusholme, Withington and Didsbury where two or three would serve the local community. Whitehead's smithy in Rusholme, shown here in about 1900, was founded by Thomas Whitehead about 1845 and continued to operate until the 1930s when the number of horses in use declined sharply and the demand for the services of blacksmiths fell away. The firm was originally at 80 Wilmslow Road, but as the business expanded, new premises were taken at 3 and 5 Monmouth Street. Finally, Whitehead's moved to 546 Claremont Road, where it ended its days. Whitehead's were also farriers and wheelwrights.

Opposite, bottom: During the nineteenth and early twentieth centuries, horses and carts were as common as motor cars and lorries are now. Where and when this horse and cart were photographed and what it was carrying or where it was going, is not recorded. All that can be ascertained is that it was photographed making its way up a ginnel or entry between two rows of terraced houses. It is possible that at the end of the passage there was a small yard and stable where the horse and cart were kept overnight. The passage itself is an indication that the houses were probably built in the latter half of the nineteenth century when every property was supposed to have its own ashpit or privy in a small backyard. The night soil carts which emptied these privies used the passages at the rear of houses to do their job, hence they had to be wide enough to take a horse and cart. Sometimes, drains were laid down the centre of the passage to take surface water and water from the houses.

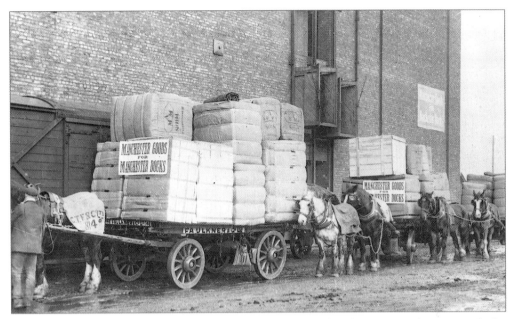

When the Manchester Ship Canal was opened in 1894, the slogan 'Manchester Goods for Manchester Docks' was introduced. Whether these carts piled with bales were used by the Manchester Ship Canal Co. as mobile advertisements or whether some manufacturers were prepared to allow the slogans to be attached to their carts as they made their way to the docks is not certain. The fact that the slogan was one which the Manchester Ship Canal Co. itself used is clear from the wall of the warehouse behind. Even today, the slogan can be seen from a train passing over the Manchester Ship Canal at Irlam – it is painted on the walls of the lock facing the railway line. The opening of the docks in Manchester and Salford enabled ocean-going vessels to reach within a couple of miles of the centre of Manchester and provided new employment opportunities for people of Manchester and Salford.

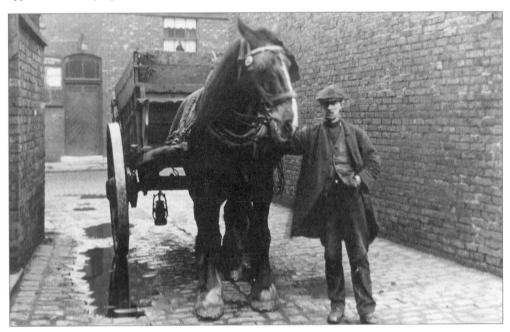

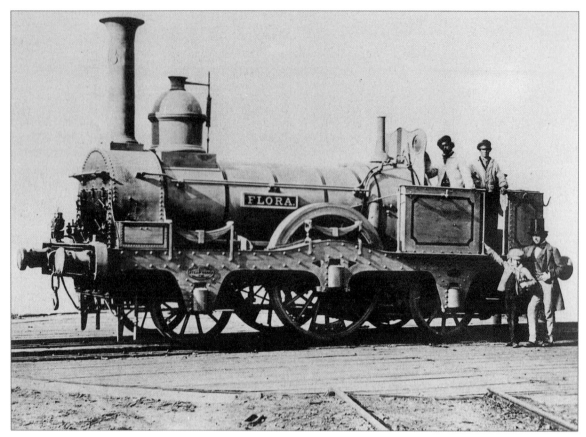

With the advent of the railways, several firms in Manchester began to manufacture locomotives, including Sharp Roberts, which made its first in 1833. However, after initial attempts, the firm gave up making locomotives to concentrate on manufacturing textile machinery, in particular the self-acting mule which had been developed by one of the firm's partners, Richard Roberts. In 1837, the firm resumed locomotive manufacturing with an order for ten for the Grand Junction Railway. These locomotives with their single pair of driving wheels were known as 'singles' and over the next twenty years the company produced over 600 of this type and its derivatives, not only for English railways, but also for European countries including France, Belgium and Holland. *Flora*, the locomotive shown in this photograph from about 1850, was typical of many built at the Atlas Works in Manchester. It was constructed for the Manchester, South Junction & Altrincham Railway, which commenced operation in 1849 as the area's first commuter line. When the line opened, there were thirteen trains a day in each direction taking between 20 and 30 minutes to complete the journey, much faster than the stage coach or horse buses. The firm continued to make railway engines in Manchester until the 1880s when it moved to Glasgow because there was no room for expansion at the Atlas Works, which were sandwiched between the Rochdale Canal, Oxford Street and Chepstow Street. In 1903, the company became part of the North British Locomotive Co. which continued to make railway engines until 1962.

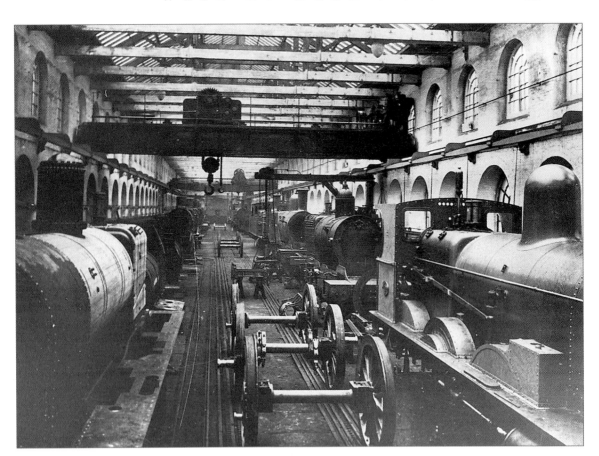

Although nineteenth-century Manchester is associated with textiles, it was also an important engineering centre with several large firms including Whitworth's, Sharp Roberts and Beyer Peacock & Company. Beyer Peacock was established by Charles Beyer, Richard Peacock and Henry Robertson in 1854 to 'make locomotives and other such light machines as the . . . works are adapted to make'. The original works covered just 1 acre of the 10-acre site in Gorton which the partners purchased. Throughout the nineteenth century further land was acquired and the works was considerably expanded. By 1902, the workshops covered 9 acres of a 20-acre site with a narrow gauge railway linking the workshops. At the beginning of the twentieth century, the company employed 2,000 people and was capable of manufacturing 150 locomotives a year. By the time the firm closed in 1966, it had made over 7,000 locomotives, around two-thirds of which were exported to countries including Holland, Sweden, Argentina, Australia and South Africa. In the early 1900s, the company developed the Beyer-Garratt articulated locomotive for which there was a large overseas demand especially in southern and central Africa, where some are still working. A number of the firm's locomotives have been preserved including at the Dutch railway museum at Utrecht in Holland, Thirlmere in New South Wales and elsewhere in Australia. One of the South African Railway's Garratt locomotives can be seen in the Manchester Museum of Science and Industry. This photograph shows one of the workshops at the turn of the century with a large number of locomotives under construction.

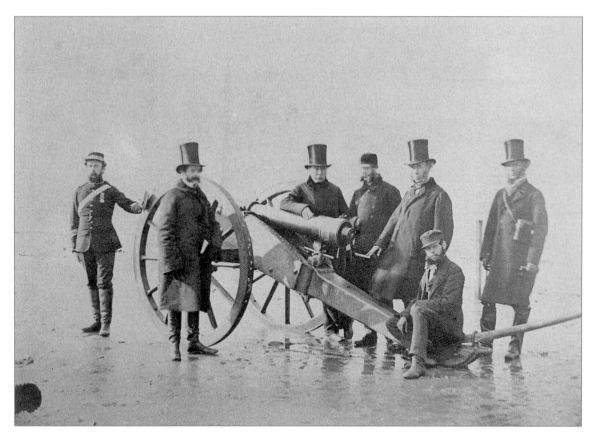

Another well-known engineering firm which had its origins in Manchester was Whitworth's. It was founded by Joseph Whitworth in 1832 in a small workshop on Port Street. The following year, Whitworth moved to Chorlton Street, where the firm stayed until 1880 when it transferred to Openshaw. Whitworth is credited with having started precision engineering when he developed a micrometer accurate to a millionth of an inch. In the late 1830s, the firm made lathes, planing machines, other machine tools and engineering equipment in standard sizes. It claimed that all were checked for accuracy. Another development was the Whitworth thread, used on screws, nuts and bolts, which became the accepted standard and is still used today. Higher engineering and machining standards enabled other firms to improve their products. For instance, it enabled Beyer Peacock to build more economical, more reliable and more powerful locomotives. The armaments industry also benefited from Whitworth's work. Whitworth made higher muzzle velocities and accuracy possible when he introduced the rifled barrel to the field gun. This photograph shows Whitworth, third from the right, and those involved with the gun's development testing it on the beach at Southport. Whitworth was also involved in less glamorous developments such as a street cleaning machine which he developed in about 1843 and used in Manchester until 1848. Sir Joseph Whitworth, who died in 1887, was one of a group of engineers who made Manchester an important centre of innovation in engineering in the nineteenth century.

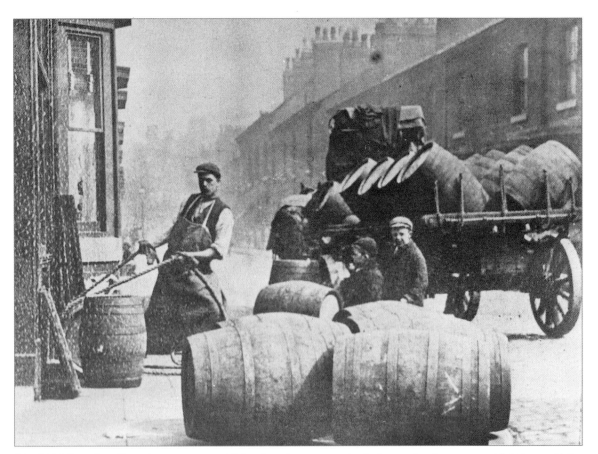

The 1830 Beer Act allowed anyone to establish a beer house, even in their own front room, provided they paid the £2 for a licence. Within a short time, a large number of beer houses had opened in Manchester and other towns and cities, often on street corners. As the nineteenth century progressed, many became tied to the larger brewers who supplied them. This photograph, taken in the 1890s, shows a brewer's dray delivering barrels to what is probably a tied beer house in a street which may be in the Ancoats area of Manchester. It is interesting to note that the way the kegs were lowered into the cellar has changed little even today: a rope is used to steady the progress of the full barrel and there is possibly a ramp down which it would roll. It appears that this house was doing a brisk trade judging by the number of barrels on the pavement. It is not recorded whose beer it was selling, but it would have been from one of the breweries which existed in Manchester at that time.

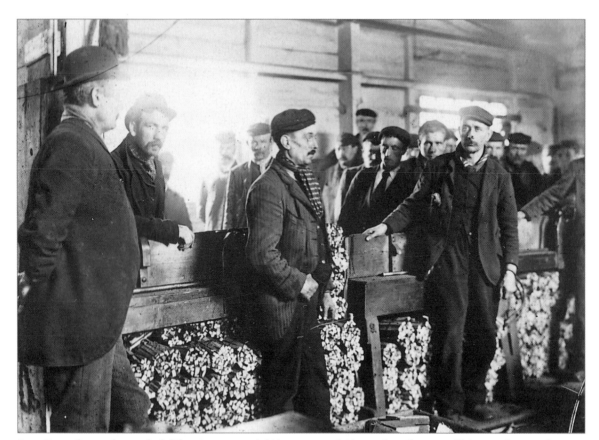

Sometimes those who worked did so to earn a night's accommodation rather than pay. This was the case for men who applied to the Manchester and Salford Methodist Mission for accommodation. Rather than charge the men, many of whom had come to Manchester seeking jobs, the Mission employed them to chop firewood, which was then sold to householders, offices and factories. The usual procedure was that men seeking accommodation would arrive around 1 p.m. and spend the rest of the day chopping wood or bill posting. In return for their labours, they received an evening meal and a bed for the night. Next morning, they left early to seek work, returning at about 7 a.m. for breakfast. Presumably those who found jobs reported the fact and were able to reserve accommodation for the following evening, for which they would pay a small sum. If they found a permanent job, the Mission made arrangements so that they had a cubicle as a bedroom rather than an open dormitory and they kept this until they had found somewhere suitable to live. This 1890s photograph shows some of the men in the wood yard with the results of their labour.

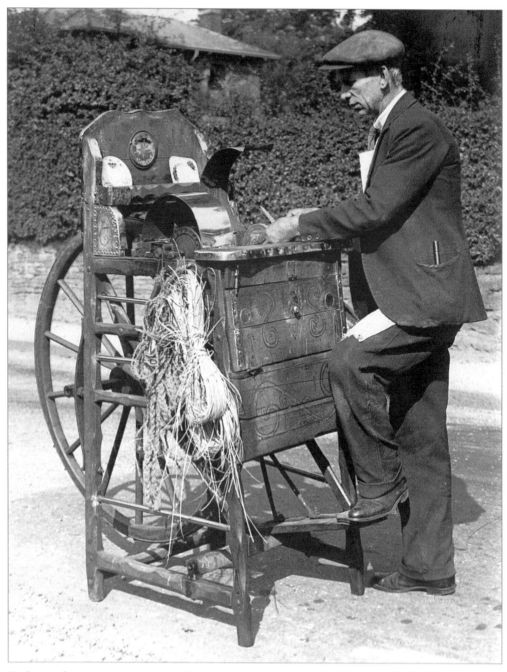

Knife grinders were a common sight in the nineteenth century and first half of the twentieth. Today, however, this useful travelling tradesman has completely vanished from our streets. The man would go from door to door with his grindstone on a trolley operated by a treadle via a belt which ran from a wheel to the spindle on which the stone was located – a simple sort of line-shafting that was found in factories all over the country at that time. When the belt was disconnected, the wheel could be used to move the equipment to the next customer. In this photograph of the 1930s, the knife-grinder appears to be wetting the grindstone, a process which resulted in a more effective sharpening surface.

Occasionally, strange illustrations make an appearance in collections. This card, with the photograph of the two men, possibly Messrs Schedule and Starbuck, appears to date from the early 1940s. Who they were and why the card was issued is not known, but it may have been an advertisement for their company or they could have been playing a joke on some of their customers.

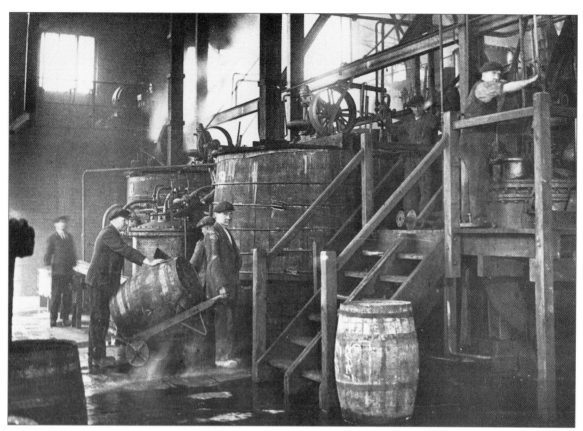

When both cotton and wool are turned into cloth, the resultant colour is rather inconsistent, tending to be greyish and not particularly attractive. From the earliest times, cloth has been bleached and dyed using naturally occurring materials such as logwood and madder. However, natural dyes produce a limited range of colours. In the late eighteenth century, the first steps were taken towards synthetic dyes by Thomas Hoyle. This resulted in a colour known as 'Hoyle's Purple'. By the middle of the nineteenth century, experiments were undertaken to produce a wider range of synthetic dyes using coal-tar. One of the earliest of these was 'mauveine', produced by W.H. Perkin senior in 1856. Gradually the number of factories producing synthetic dyes increased to meet the demand from the textile industry for a wider range of colours. In 1876, Charles Dreyfus founded the firm known as Clayton Aniline to produce dyes from coke oven benzole. The firm was very successful, gradually increasing not only its range of colours, but also its size. In 1911, it was taken over by CIBA Ltd and eight years later, CIBA joined with Geigy and Sandoz to form CIBA-Geigy. Throughout the interwar period, production and the range of colours continued to expand as dyes had to be found for the increasing number of synthetic materials which were being developed. This photograph, taken in 1933, shows part of the Clayton Aniline Plant. Note that belt-driven machinery is still the order of the day, that much of the equipment is made of wood and that the men are not wearing shoes or boots, but wooden clogs, which were not corroded by the acid used in the manufacture of the dyes and other chemicals at the factory. There is no form of protective clothing, not even goggles.

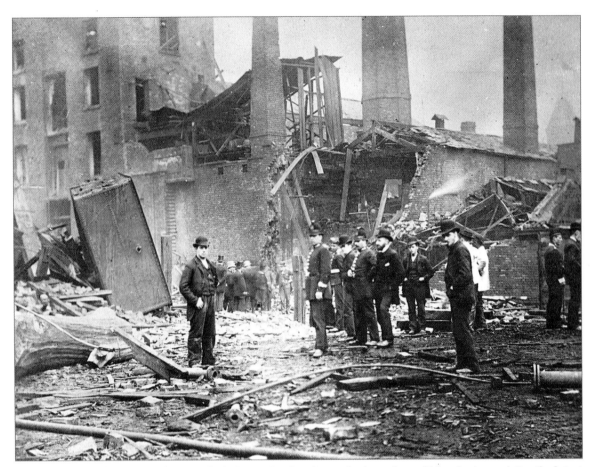

There was an explosion at Roberts, Dale & Co. in Cornbrook, on the boundary of Manchester and Stretford, just after noon on 22 June 1887 when a stove used for drying prussic acid blew up, killing one person. The explosion, which devastated the works and the surrounding area, was said to have been heard in Oldham. The local press reported the event extensively, the *Manchester Guardian* taking 3½ columns to describe the event and a further 1½ to cover the inquest into the death of the person who tried to extinguish the fire. Asked to comment on the explosion, one of the partners, Mr Roberts, told the reporter he did not know the cause, but the reporter added that 'Mr Roberts did not seem in a communicative humour'. The firm never fully recovered from the explosion.

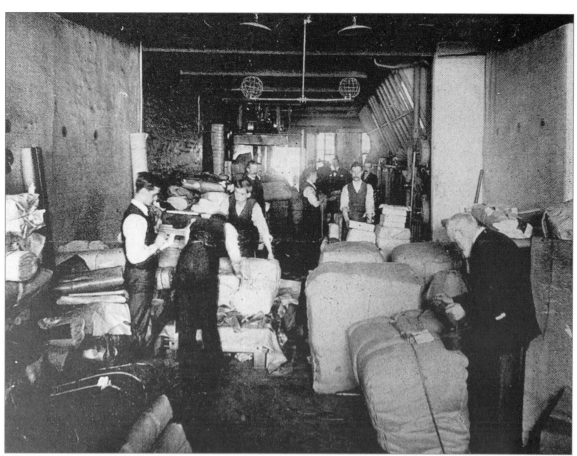

Although Manchester was an important manufacturing centre, it was not a large producer of cotton yarn or cloth. Manchester's importance to the textile industry was its commercial and finance business. It was in Manchester that many of the mills had warehouses where they could display their products to would-be customers from both Britain and overseas. In 1838, the first purpose-built textile warehouse was constructed for Richard Cobden on Mosley Street. Within a short period of time several more warehouses had been erected, each bigger and grander than the last until the completion of Watt's Warehouse on Portland Street in 1858. Whole areas became devoted to warehousing with their grand entrances up a flight of steps, open rooms where cloth could be examined and basements where packing took place. This photograph shows the basement of one of Manchester's warehouses where cloth is being packed in waterproof fabric and hessian. Work was very hot and dirty for those in the packing rooms, yet all the men are wearing waistcoats, which was an accepted part of the period's dress code.

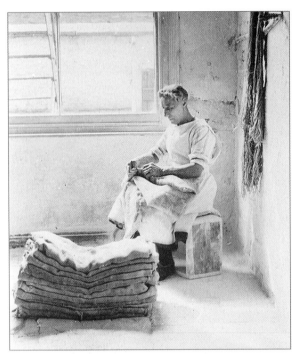

Although some firms employed large numbers of people, there were also a great many small ones involved with producing a wide range of products. A glance through a trade directory for the end of the nineteenth century reveals a vast range of small manufacturers; many were either one-man concerns or employed only a few people. The three illustrations here show three examples of small firms or businesses found in Manchester in the late nineteenth and early twentieth centuries. The photograph on the left shows a man quietly stitching bags. They appear to be made of hessian or a similar material and could have been used in the textile industry for carrying cotton between mills or for foodstuffs such as flour. The illustration below shows a carpenters' workshop where three men appear to be discussing a problem with a job, some aspect of the news or just generally chatting before resuming work. The picture on the right is again of a small workshop, which appears to be a joiner's shop, with a man, possibly the owner, posing for the photographer with what looks like a chisel.

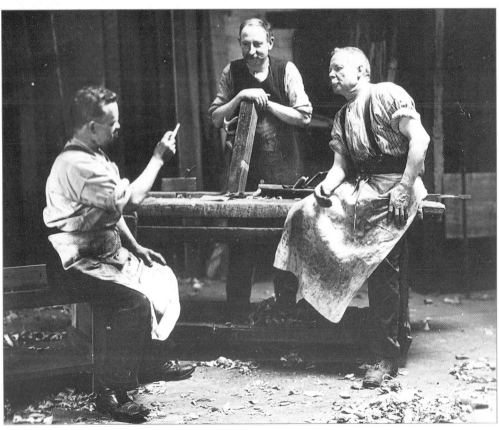

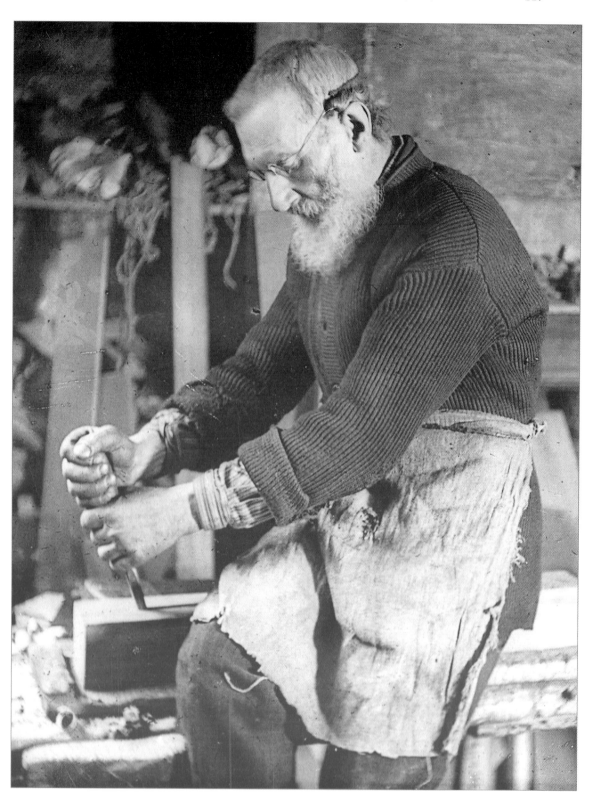

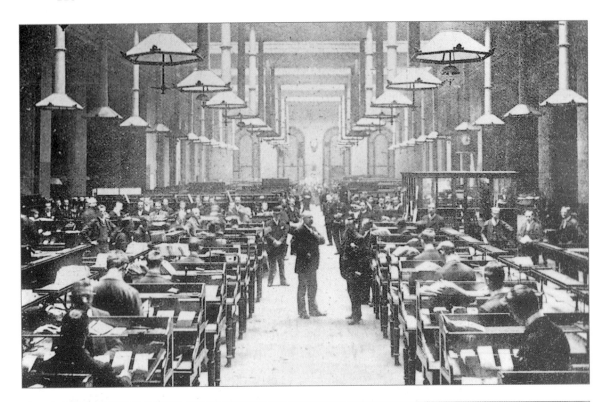

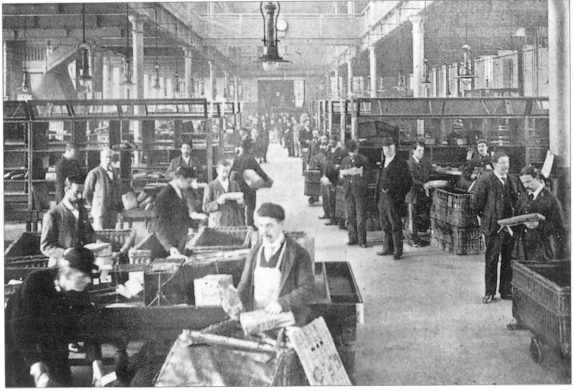

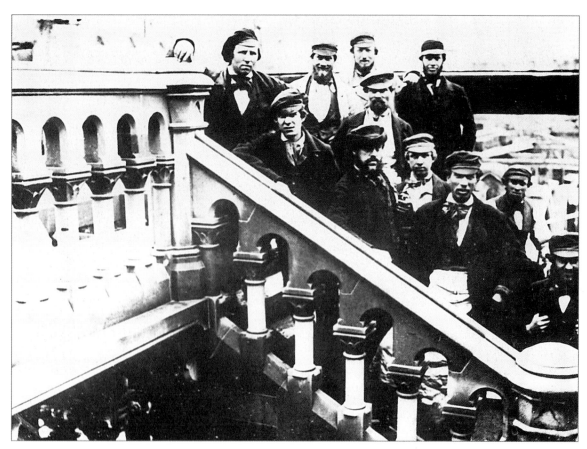

In the middle of the nineteenth century, there were three prominent architects working in Manchester whose surnames began with the letter W. These were Edward Walters, who designed the Free Trade Hall and numerous warehouses, Thomas Worthington, who was responsible for the Memorial Hall, the Albert Memorial and the Minshull Street Police Courts, and Alfred Waterhouse, who designed the Town Hall, Strangeways Prison, Owens College and the Assize Courts. The work of these three stands out as making a major contribution to the townscape of Manchester. Fortunately, many of the buildings which they designed have survived the passage of time and can still be admired today. However, the Assize Courts, which stood between Bury New Road and Strangeways Prison, have vanished. The building was designed by Waterhouse and completed in about 1868, at the same time as the prison. This photograph is one of several taken during construction and shows some of the men responsible for the work. The balustrades give the impression of grandeur. Around some of the columns inside were carvings of old punishments, a sort of warning to those who were on trial of what might have happened to them under earlier regimes. The Assize Courts were seriously damaged in the Christmas and Whitsun air raids of 1940 and 1941 and had to be demolished.

Opposite: In 1840, Rowland Hill introduced the Penny Post which enabled letters to be sent any distance for the sum of 1*d*. Previously letters had been charged both by distance and weight. The new arrangements resulted in a gradual rise in the volume of mail. Sorting offices became hives of activity as outgoing mail was organised for despatch to other parts of the town or country and incoming mail was made ready for delivery. These two photographs show the letter sorting room at the main post office (top) and the parcel sorting department (bottom) in about 1900. The busiest time in the sorting office was around Christmas when there were complaints that the public tended to leave posting to the last minute. For the parcels department, it was busy all year round, handling over 100,000 items every week in 1900.

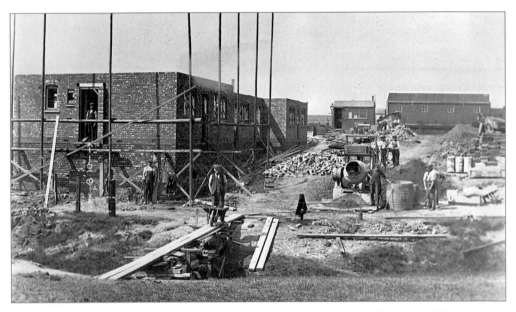

Between the two world wars, local authorities were allowed to begin building council houses in an attempt to eliminate the slums which had grown up in the nineteenth century. In order to embark on a programme of slum clearance, new housing had to be built on the outskirts of the city. One such area was Newton Heath around Ten Acres Lane and Briscoe Lane. Here, the houses had to have very deep foundations to provide stability on account for the nature of the land. The house on the left had to have foundations 8ft 10in deep while on another part of the site, the foundations are shown as being over 13ft deep. Whether these houses were popular with their tenants is not certain because they were close to a gut works, the smells from which would have been very unpleasant. The factory took the parts of animals that could not be used for food, rendered them down and converted them into products for the textile industry.

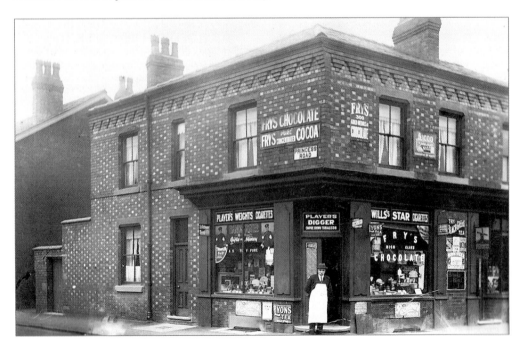

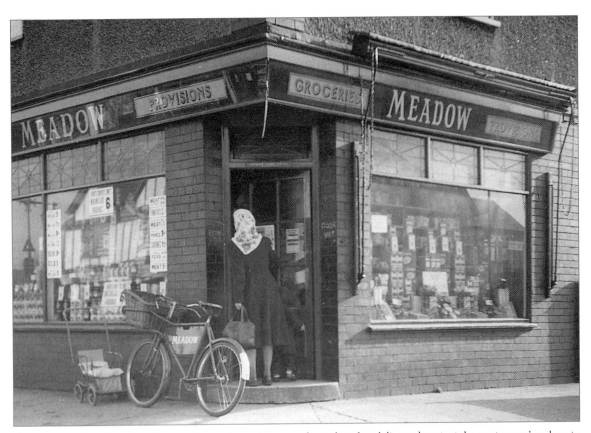

This corner shop clearly sold groceries and provisions and employed a delivery boy to take customers' orders to their homes. The full name of the firm that owned this store was Meadow's Dairy Company and it was a provision dealer with about sixteen shops in 1938. These shops were to be found in Salford, north and east Manchester and the Moss Side area. The location of this shop cannot be identified from the photograph as there are no street names and no house numbers visible. In the window there are numerous bills which give details of prices. Over the entrance is the statutory notice which indicates that the premises were licensed to sell either tobacco goods or alcohol, or even both. At the side of the delivery boy's bike is a pram, which from its size seems to be one which a little girl would have used for her dolls.

Opposite, bottom: An important part of any community was the corner shop. Some were tobacconists and sweet shops while others sold food. This particular store, pictured in the late 1920s, stood at the corner of Princess Road and Royle Green Road in Northendon. The local directory gives the address as 42 Royle Green Road. In 1938, the occupier was a Henry Hudson Moult, shopkeeper. The advertisements on the shop itself are typical of the 1930s. Some of the products will be familiar to the older generation of readers – Lyons tea, Fry's cocoa and chocolate, Black & Green's tea, Player's Weights cigarettes, which were still being produced in the 1950s, and Player's Digger tobacco, which was still available until about 1998.

The summer of 1911 was a period of much industrial unrest which affected both industry and transport. In Manchester, trams failed to run, carters went on strike and railway services were decimated. The military had to be brought in to protect carters who were prepared to work and deliver food to the markets. This photograph shows a detachment of the 16 Lancers at Hulme Barracks whose task it was to protect food supplies. The effects of the strike were felt across the whole community, even by holidaymakers who found that although they could get back to Manchester, there was no one to help them with their luggage when they reached the city.

These two have just arrived at Victoria station in August 1911 and cannot find a porter to help them with their luggage. According to the original caption, when the photograph was published, a kind member of the public helped them with their bags. Although the 1911 strikes affected the mining industry and transport system in the main, there were also strikes for higher wages in Manchester's engineering industries.

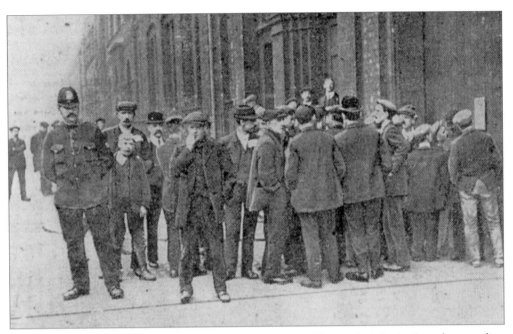

These demonstrators are outside the works of Armstrong, Whitworth & Co. in Openshaw reading the notice which the management had pinned to the door announcing that the firm would pay the workers the going rate as agreed in what were described as the 'recent settlements'. Other engineering employers took the same line and gradually the men returned to work and the strikes ended.

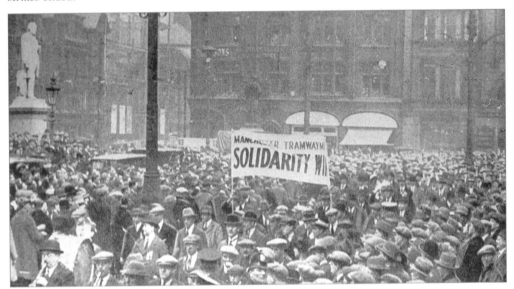

Between 4 and 12 May 1926, Britain was affected by a general strike. Manchester was relatively peaceful compared with some other towns. There were spasmodic outbreaks of violence, such as the destruction of two vans belonging to the LMS at Smithfield Market and a lorry being set on fire by Oldham Road Goods Depot. There were also reports of a van driven by a volunteer being attacked by a crowd at London Road station, but intervention by the police prevented it being destroyed. This photograph shows tram drivers and other involved in the General Strike attending a rally in Albert Square.

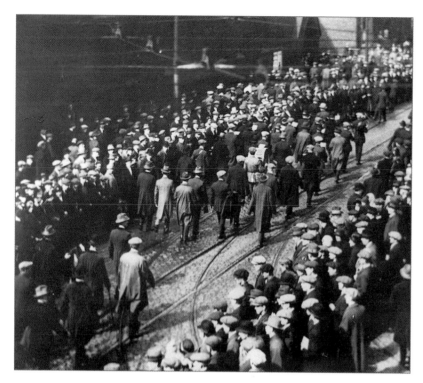

Transport was heavily disrupted. Although electricity supplies were maintained, the unions threatened that if any attempt was made to run the trams, they would shut down all the power stations – no attempt was made to run the trams throughout the period of the strike. Trains were also badly hit with few services at the beginning of the strike, but gradually the number increased, making it slightly easier to get to work. In this photograph, striking Manchester Corporation Transport Department employees are seen marching along Hyde Road to a rally in central Manchester. They are watched by other workers.

For those not involved in the strike, there was the problem of getting to work. Some were able to get lifts with friends while others cycled, walked or made use of transport run by private bus and coach companies. Even lorries were pressed into service, as this photograph shows.

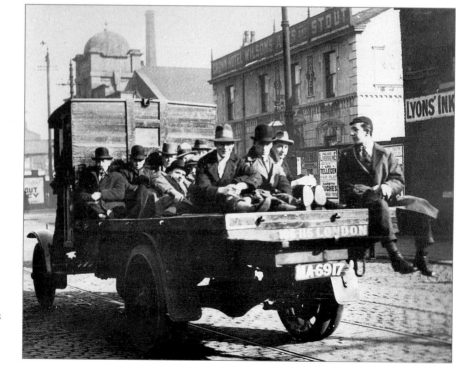

CHAPTER FIVE

. . . AND WHEN NOT
AT WORK

Many people believe the nineteenth century was a period when there was little time spare for activities other than working, sleeping and eating, that lives were ruled by the factory bell or hooter and that for the average working man or woman, wages were only just sufficient to provide for food, heating and the rent. However, this picture is far from accurate: working hours were gradually reduced and the Saturday half-holiday movement, led by William Marsden and George Wilson, became established, allowing firms to close at 1 p.m. on Saturdays, and this became noon in the early twentieth century.

During the nineteenth century the average working person saw a gradual increase in the amount of money they had to spend. This was brought about by a combination of steadily rising wages and relatively stable prices. It has been said that in the middle of the century the habit of saving, either with a friendly society or a bank, began to filter down to the working classes. In addition, having 'a little to spare' was no longer the preserve of the upper classes. The existence of this extra cash, according to James Walvin in his book *Leisure and Society, 1830–1950*, was 'a fact of major significance in the evolution of new recreations'. It must, however, be remembered that there were still many who could not afford to save and who continued to have a hand-to-mouth existence.

The nineteenth century also saw the beginnings of annual holidays, or wakes weeks as they were referred to in the north-west. Employers began to appreciate that maintenance on machinery could be carried out more efficiently if their employees were absent and so they started to grant a week off work – without pay of course. There were also 'unofficial holidays' when workers took an extra day off without permission. The best known of these was 'Saint Monday', when you either did not turn in for work or if you did, achieved very little.

There was a realisation that those who were employed in warehouses, offices, banks and shops did not get the same time off as those in mills and factories because there was no need for these organisations to close down for maintenance purposes. Then, in 1870, the Bank Holiday Act was passed. In the eighteenth century, the Bank of England was closed for 47 days a year, which was reduced to 44 in 1808, to 40 in 1825, 18 in 1830 and just 4 in 1834 (Christmas Day, Good Friday, 1 May and 1 November). The 1870 Act forced banks, warehouses and shops to close down for certain days and created long weekends.

The greatest changes took place in the latter half of the nineteenth century as the benefits of giving people an opportunity to take a break began to be appreciated. Before about 1850 any kind of break was frowned upon. Alexis de Tocqueville, visiting England in 1835, commented that one 'Never heard the gay shouts of people amusing themselves or music heralding a holiday. You will never see smart folk strolling at leisure in the streets or going on innocent pleasure parties in the surrounding country.' In the same year, another visitor to Manchester, Van Raumer, wrote that 'the working people have generally no means of excitement or amusement at their command during the week . . . and even Sunday, stern and rigid as it is here, brings no recreation or enjoyment'.

Sundays tended to be dominated by those who believed that people should do nothing on the Sabbath except go to church or sit at home. These people represented all denominations and were generally referred to as Sabbatarians. In fact, many working people did not go to church on Sunday, but instead went to the local pub. The only people who benefited from the Sabbatarians' approach were the publicans. In 1856,

During the late nineteenth century there were several references to parks having 'gymnasiums' for boys and girls. This description gives the impression that these were purpose-built specially equipped, supervised facilities. However, nothing could be further from the truth as this photograph of a 'gymnasium for children' at an unnamed park in Manchester shows. The word meant that more pieces of equipment than usual were installed. It appears that by the time this photograph was taken, in about 1914, the policy of having one such area reserved for girls and another for boys had been abandoned and that all children played together.

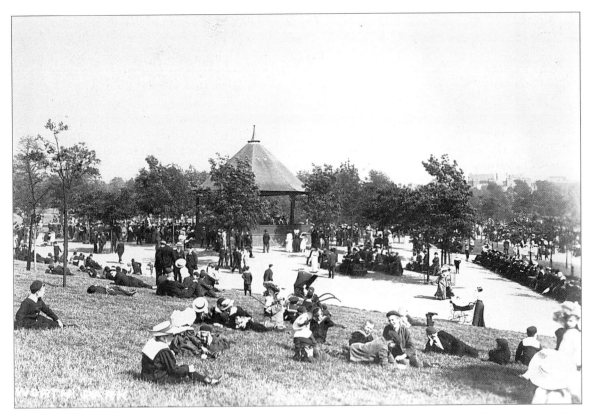

When Whitworth Park was established in the 1890s, the main intention was to provide a place where children could play away from the roads and streets. Consequently, many of the restrictions found in other parks were not enforced here. For instance, there was no attempt to stop the children playing on the grass, while the lake was shallow and toy boats could be sailed on it. The one concession made to adults was the erection of a bandstand. This Edwardian photograph shows children, who appear to be in their best clothes, sitting on the grass while the adults listen to a concert.

Manchester introduced band concerts in parks in the city, but there was strong opposition from the Sabbatarians and the experiment was not repeated in following years. However, it is worth noting that during the period when the concerts were held, there was a marked decrease in drunkenness according to the police and that when the concerts stopped, the rate of drunkenness rose again.

De Tocqueville and Van Raumer echoed comments made by a local man, James Philip Kay, who had written in 1833 that 'the entire labouring population in Manchester is without any season of recreation, and is ignorant of all amusements, excepting that very small proportion which frequents the theatre. Healthful recreation in the open country is seldom or never taken by the artisans of this town.' Even Parliament recognised that lack of open spaces and other recreational facilities were an evil. In 1844 the Short Time Committee reported that 'Schools and libraries are of small use without the time to study. Parks are well for those who can have time to perambulate them and baths of little use to dirty people who do not leave work until 8pm.'

Many of the problems which arose in the first half of the nineteenth century had been caused by rapid industrialisation and the growth in the industrial towns of the north of

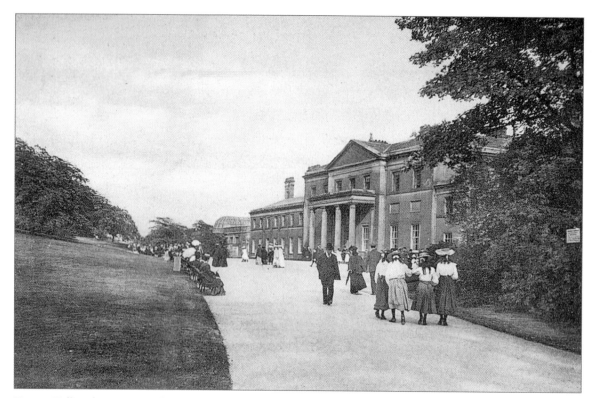

Heaton Hall and its associated park were owned for a long period by the Egerton family, later to become the Earls of Wilton. The present Heaton Hall was designed by James Wyatt in 1772 to replace an earlier building. The new house was sited in an elevated position with extensive views over to the Pennines and the Irwell and Irk valleys. In 1902, the Wilton family were faced with heavy death duties after two earls died within a few years of each other.

England. Open space was at a premium and it was not until the early 1840s that reformers began to appreciate the importance of creating areas where working people could walk and get away from their overcrowded living conditions. It was claimed that the lack of open space had caused the decline in certain sporting activities such as football. However, by the end of the century, organised sport, including football, rugby league and cricket, was beginning to make a come back.

This selection of photographs aims to give an impression of the wide range of activities which people enjoyed in Manchester in the latter half of the nineteenth and early twentieth centuries.

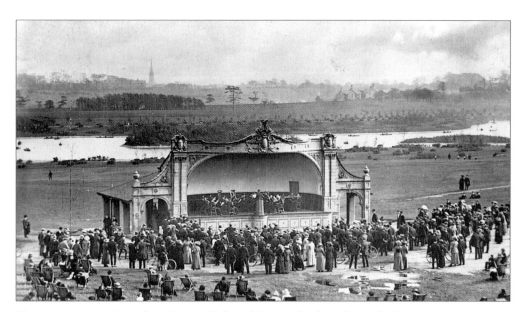

There were suggestions that Heaton Hall and its parkland might go for housing or even to be turned into an industrial estate, but in 1902, Manchester City Council purchased the hall and the 600-acre estate to preserve it as an open space for the residents of north Manchester. The following year, the estate was incorporated within the boundaries of the city of Manchester. The council decided to maintain the openness of the estate although flower beds were planted close to the hall, giving it a somewhat formal setting and contrasting this area with the rest of the park.

Although Manchester decided not to landscape the park at Heaton Hall, certain alterations were made to the area in the years before the First World War. In order to attract visitors, a lake was constructed and when, in 1912, the former Town Hall on the corner of Cross Street and King Street, was demolished, it was decided to re-erect the columns from the front portico by the lake in Heaton Park. This atmospheric photograph was taken in the 1930s and shows the columns standing high above the trees.

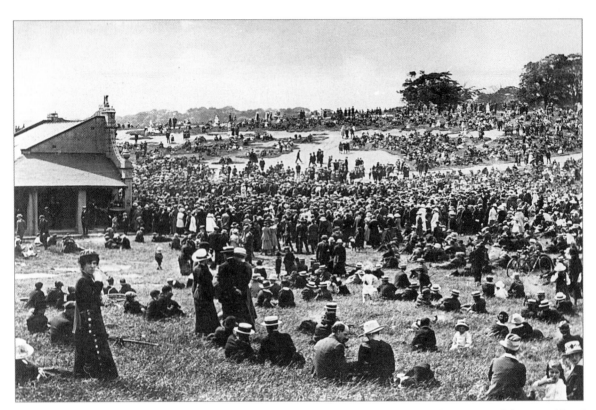

Some developments did take place at Heaton Hall including the construction of a 12-acre lake, capable of accommodating 2 motor launches and 100 rowing boats, which can be seen behind the bandstand in the picture at the top of page 129. The park soon became popular with visitors and was a venue for Whit week trips by Sunday schools.

Opposite, bottom: Official openings provide the opportunity to photograph civic dignitaries and other leading citizens taking part in activities that they would not otherwise consider. For instance, this photograph was taken in 1910 after the Lord Mayor and the Lady Mayoress officially opened Platt Fields Park. As part of the opening ceremony, the official party was taken for a boat trip around the lake watched by large numbers of people who had turned out to attend the event. One gets the impression that some of those in the boat were not really enjoying the trip and considered it beneath their dignity.

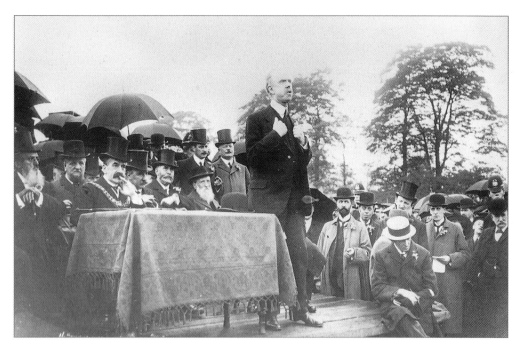

When Manchester acquired the Platt Hall estate in 1907 and converted it into a public park, William Royle, who led the campaign to save the estate for the public, ensured that the opening of the new park was a grand civic occasion. Although the weather was wet, a large crowd turned out to witness the event. The speaker is believed to be William Royle himself and there is a note at the bottom of the photograph, added when it was printed, which says 'This is a grand day for Rusholme.'

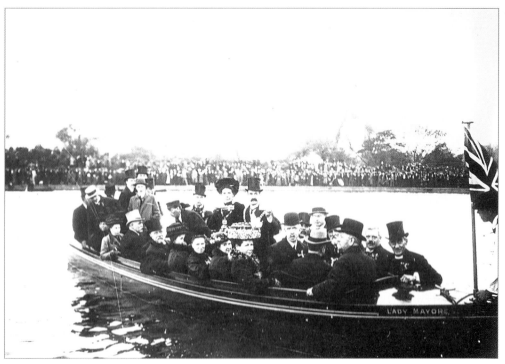

One of the events that took place for many years in Didsbury was the annual show, which was held on the Simon playing fields. The first was organised in 1901 although there is evidence that there were agricultural shows in the area in the nineteenth century. The Didsbury Show was organised by a body known as the South Manchester Show and was held on August Monday (the first Monday of that month) each year. Entry was free and it always attracted a large crowd. This photograph was taken at the 1910 show and records the judging of the horse and carriage class. The event was last held in 1966 when the fields were taken over by Manchester City Council which refused to allow the land to be used for the show.

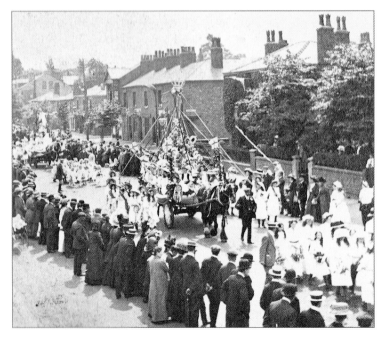

In 1911, Didsbury marked the coronation of George V and Queen Mary with a procession through the streets of the village to Ford Bank. The local papers described the event as 'a pretty little spectacle' which 'did great credit to the organisers'. The procession included floats entered by various Didsbury organisations together with representatives of the council and organisers. According to Fletcher Moss, Didsbury's local historian at the beginning of the twentieth century, everyone in the village was expected to take part and make some contribution towards the event. The floats had themes including 'The Union Jack', 'Maypole,' 'Army and Navy' and decorated prams. This photograph shows just one small portion of the procession as it passed Didsbury police station in the centre of the village.

During the 1920s, outings in charabancs and large cars became very popular with groups from pubs and large families. This photograph was taken in the mid-1920s and shows a family from Moston about to set out for a day trip either into the country or to the coast. As many people could not drive or even afford to buy a car of this size, it is probable that the one in the picture was hired for the day together with the driver. (*Mrs L. Connor*)

The arrival of the railway train ushered in the era of mass transportation not only to and from work, but also for recreational purposes. During the 1840s, there were a number of well-reported railway excursions from Manchester and other parts of industrial Lancashire to the coast, usually to Fleetwood and then Blackpool. Trips to the countryside and seaside were also organised by Sunday schools, churches, trade unions and many other bodies. The Factory Inspectorate even gave information to firms on how to book a train or arrange an excursion for employees. This photograph, probably taken in about 1910, shows a group of young people waiting at a Manchester suburban station for a train. It is not clear whether this was a Sunday school trip or one organised by a local firm. However, there is a clue in that the card was sent to someone in Droitwich and the sender gives the address from which it was despatched as Alma Park School, which is in Levenshulme. It is possible that the station might be Levenshulme Hyde Road, which was on the Chorlton-cum-Hardy to Fairfield line and that the people in the photograph are in some way connected with the school. (*J. Ryan*)

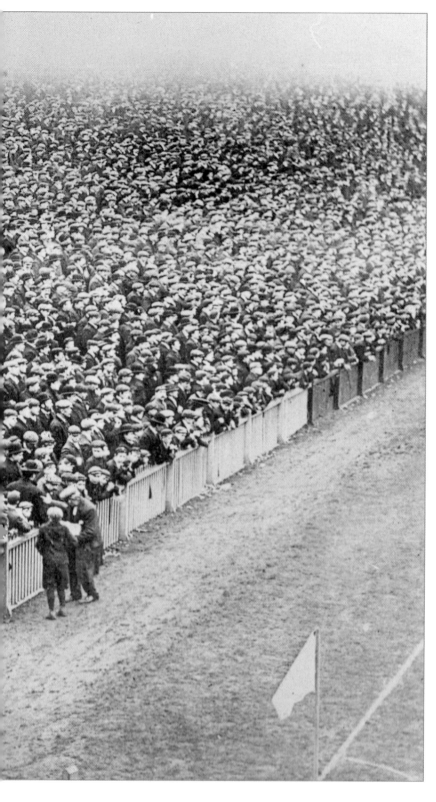

During the last two decades of the nineteenth century, interest in football revived. Many teams were established by Sunday schools, clubs and factories, attracting large crowds of spectators. Some of these amateur clubs gradually became professional and entered the football league. The two Manchester clubs were not admitted to the league until some years after it was established. Manchester City and Manchester United have very different origins. Manchester City began as a church team which merged with another run by a youth club, whereas Manchester United began as a works team. Manchester City was known as Ardwick FC until 1894 and had its ground at Hyde Road until 1923. Manchester United started life as Newton Heath Loco and had several grounds in the Clayton area before moving to Old Trafford in 1910. This photograph shows the crowds at a football match in Manchester sometime before the First World War, but unfortunately the location and teams are not recorded. Note that the spectators are all standing and are exposed to the weather. Seating and covered stands are the order of the day now.

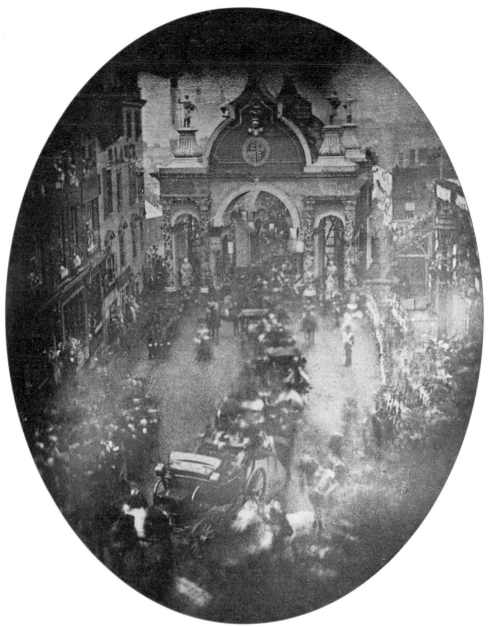

On 10 October 1851, Queen Victoria paid her first visit to Manchester and was warmly received by
large crowds lining the streets. The Queen entered Manchester over Victoria Bridge from Salford,
where she had inspected a huge gathering of Sunday school children in Peel Park. Triumphal
arches were erected across Victoria Bridge and in St Ann's Square while the streets were decorated
for the visit. Her route to the Exchange, where she received an address of loyalty from the Mayor
and Corporation, took her along Market Street, High Street, Swan Street, Oldham Street, around
Piccadilly to Mosley Street, Peter Street, Deansgate and St Ann's Square. As a result of the reception
she received, Victoria authorised the Exchange to be known as the 'Royal Exchange' and two years
later, Manchester was granted city status. This photograph, taken on the day of the visit, shows the
royal procession entering Manchester. The arch and the carriage are clear, but as the length of
exposure was long, anything moving appears to be blurred.

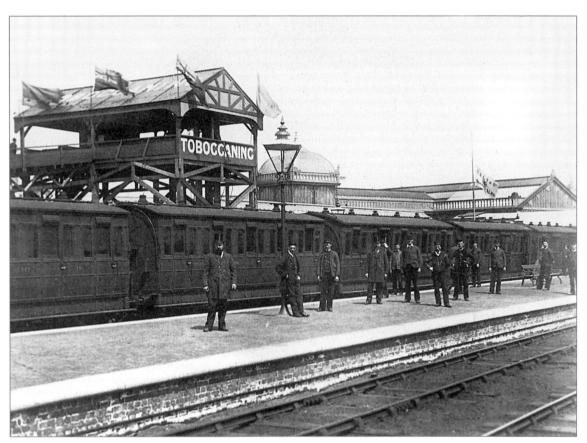

In 1887, a large exhibition was held just outside Manchester in Old Trafford at which the products of the various firms in the region were displayed. It was organised to mark the fiftieth anniversary of Queen Victoria's accession to the throne. The exhibition, which was on the same site as the Art Treasures Exhibition of 1857, attracted a large number of visitors and included a large re-creation of the Market Place in Manchester. In order to attract members of the public to the event, the station which had been built for the 1857 exhibition was re-opened. Special trains were run from Manchester as well as from other parts of the country. Firms took their employees to the exhibition not only for a day out, but also to enable them to see their own products on display alongside those rival firms were producing. According to reports, the event attracted huge crowds during Whit week and they appear to have consumed vast amounts of food and drink. This photograph shows the station and the staff required to operate it for the duration of the exhibition – May to October. When the event closed, the station remained open, becoming known as Warwick Road, and was used extensively by those who attended Lancashire County Cricket Club's matches at Old Trafford, just a short walk away.

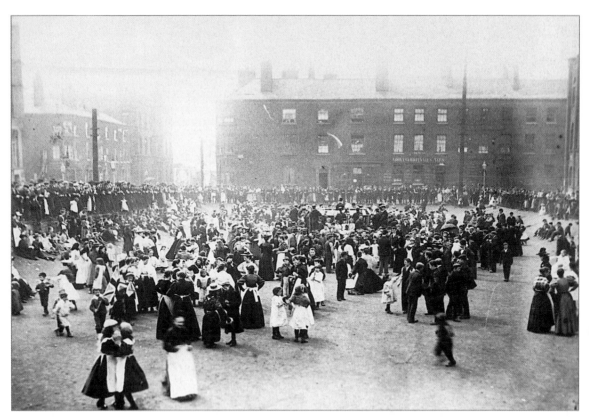

The exact location of this street party is not known, but the photograph was taken on 22 June 1897 during the celebrations of Queen Victoria's diamond jubilee. According to the newspapers, Manchester treated the day as a public holiday with church services and a civic lunch in the Town Hall. School children were provided with a breakfast while 'waifs and strays' who did not bother people by trying to sell them firewood and matches were provided with a meal by the city council. The parks were full of people with children playing and bands performing to appreciative audiences. The *Manchester Guardian* applauded the wisdom of the City Council in spending a 'few thousand pounds' on events in Manchester which attracted visitors from the surrounding area.

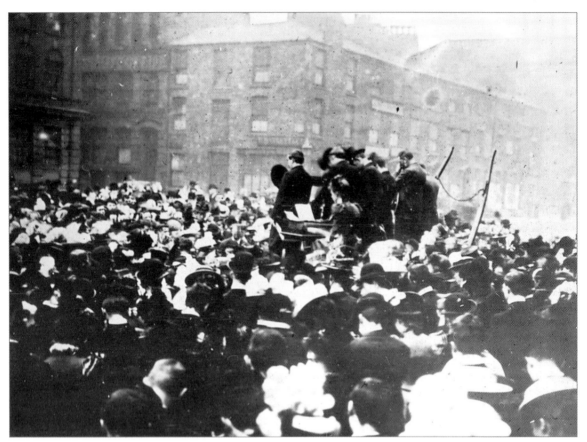

The Manchester and Salford Methodist Mission was not only involved in helping those who lived in the poorer parts of central Manchester and Salford, but also held religious services both in the Methodist Central Hall on Oldham Street and in the open air. This outdoor service in about 1897, which appears to have been well attended, was being held in Stevenson Square, only a short distance from the Central Hall. The arrangements appear to have been very thorough for not only is there a choir on the platform, but one of the sisters is playing what looks like a harmonium. The platform was a very simple structure – a cart with planks laid across it, the shafts of which can be seen to the right of the choir and person leading the service.

In the mid-nineteenth century, some lamented the gradual disappearance of old customs but in some parts traditions continued to be observed and became focal points for local events. One such area was Gorton where the annual rush cart procession continued until about 1875. This photograph appears to be of the Gorton rush-bearing, probably towards the end of its existence. Rush carts were certainly in use in Gorton before 1775 when there is a reference to two. The idea was that fresh rushes were provided for the floor of the church. According to Higson in his *Gorton Historical Recorder*, there was rivalry between Gorton and Openshaw for many years as to which district produced the best rush cart, but after 1775, only the people of Gorton continued with the tradition. Not only did the event enable the local people to show their skills in decorating a rush cart, but it was also a chance to have a good time.

Opposite, bottom: As this group of people approaches, the man on the right of the picture respectfully touches his cap, but is it out of politeness for the lady or is it out of recognition for the gentleman on the left of the group? The gentleman is Keir Hardie, leader of the Labour Representation Council. When Hardie returned from his foreign visits in May 1908, he attended two meetings in Manchester on 3 May. The second was for members of the Manchester and Salford Independent Labour Party (ILP). It was held at the Co-operative Hall, Downing Street. Both events were chaired by Councillor J.M. M'Lachlin from Levenshulme and he may be the person on the lady's right.

During the latter part of 1907 and early 1908, the leader of the Labour Representation Council, Keir Hardie, made visits to several countries including South Africa and India. Travel was slow compared with today as long overseas journeys had to be made by boat. When Hardie returned home, the first event he attended was in Manchester, which was reported as being a 'welcome home' meeting. In fact, there were two meetings held in the city. The main one was at the Free Trade Hall, which was filled to overflowing. Hardie gave a wide-ranging speech about his overseas visits, what he had seen and learned about the conditions and problems in India and South Africa. Not only did he attack government policies, blaming the presence of plague in India on 'western commercialism', he also criticised politicians like Churchill for their attitudes towards the problems he found in the countries he visited. It is not certain where this photograph was taken or what the men in the picture are reading, but in the background, covering some posters for a temperance 'Ham, Tea and Social' evening, is an advertisement for Hardie's visit.

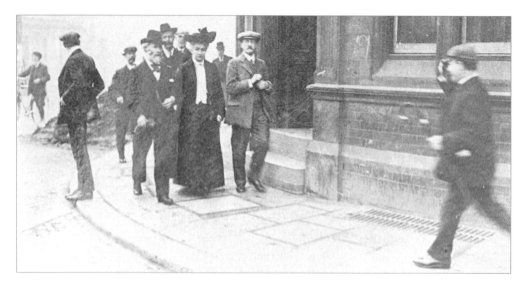

The first Whit walks were organised by the Church of England in 1801 to ensure that children from the various Sunday schools visited Manchester's parish church at least once a year. Gradually, other denominations adopted the idea of a religious walk during Whit week, which was a sort of 'wakes week' in Manchester and the time when Manchester races were traditionally held. One of the most colourful of the Whit walks, especially in the twentieth century, was the Roman Catholic event, which was held on the Friday in Whit week until the religious connection with the late May holiday was broken in the 1960s. Many of those who attended Roman Catholic churches came from other parts of Europe and the Whit processions enabled them to dress in national costume. In 1936, 18,000 people took part, representing twenty-six churches and accompanied by thirty-six bands. They walked 4 miles from Albert Square, Peter Street, Deansgate and Market Street to Piccadilly. This photograph of the late 1930s shows the Italian community in Piccadilly with the Madonna from St Michael's Church, George Leigh Street in Ancoats. When the procession finished, the walkers returned to the church where the statue was set down. The people sang the English and Italian national anthems followed by the 'Ave Maria' and 'Faith of Our Fathers'.

Opposite, bottom: Sitting and watching the world go by was a popular pastime for some sections of the population. This photograph was taken in the late 1890s and shows the walls of the Infirmary in Piccadilly. The original photograph was published by the Manchester and Salford Methodist Mission in one of its annual reports and then turned into a postcard; it may be that these people, who were either casual labourers or out of work, were photographed to illustrate the type of person the Mission was trying to help. Sitting in either Piccadilly or other places in central Manchester was and still is popular at lunchtime on warm summer days.

Although meetings were known as 'Manchester Races', the racecourse was never in the city – races were always held in Salford. The earliest reference to horse racing in Manchester goes back to 1687, but races did not become regular until 1772. The original racecourse was at Kersall Moor, but in 1847 the events were moved to Castle Irwell, where they stayed for twenty years until new owners of the land refused to renew the lease. They were opposed to horse racing, arguing that it encouraged betting which led to poverty and misery. A new racecourse was built at New Barns, where it remained until 1902 when the land was used to build no. 9 dock. Manchester races returned to Castle Irwell, where a modern course was laid out on a 116-acre site. The races always attracted large crowds, even in wartime as this 1941 photograph shows. The most famous event was the Manchester November Handicap. The racecourse closed in 1963 and the site is now part of Salford University. It should be noted that horse racing was held at Heaton Park between 1827 and 1838 on a track laid out by the Earl of Wilton and intended for the entertainment of his guests, although members of the public did manage to gain admittance.

ACKNOWLEDGEMENTS

In the first two volumes of this series on Manchester, I expressed my gratitude not only to all those who have collected and preserved photographs of Manchester in the past, but also to those who are still doing it today. As towns and cities change, it is very important that a pictorial record of the town is maintained for future generations of historians and Mancunians so that they can see what the city looked like at the end of the twentieth and beginning of the twenty-first centuries. The thanks of the current generation of local historians should go to all those in the past who have kept photographs and postcards of places so that we can see what the city of out forefathers looked like. New material keeps coming to light.

At the same time, thanks should be expressed to all those who have written about their experiences in Manchester as these accounts can often help to identify a picture or the picture can enliven what they have written. Nor should newspaper reporters be forgotten; they assiduously collected news stories in the past, and wrote detailed reports, far more detailed than anything which appears in the press today. Their work can provide the background to an event or street scene.

My grateful appreciation is due again to Manchester Central Library, to John Ryan for the loan of some of the more interesting postcards, the Manchester and Salford Methodist Mission, Mrs L. Connor and Manchester City Planning Department for allowing the use of photographs from their collections. If I have forgotten anyone, I am very sorry and hope that you accept my apologies.

I would also like to thank David Brearley who has copied many of the lantern slides which have been used in this book. Without his help, the reproduction of some of these images would not have been possible. I would also like to thank Simon Fletcher of Sutton Publishing for his interest and helpful comments and Sutton Publishing in general for their policy of trying to make illustrations of times gone by more generally available.

Finally, I would like to express my grateful thanks to my wife, Hilary, for reading through the drafts of the captions and making helpful comments, spotting things I had overlooked or not explained clearly enough. Also, thanks are due to Peter and Anna who tolerate their father's enthusiasm for Manchester and collecting materials on the city.